OTHER BOOKS BY COURTNEY MILNE

Prairie Light, 1985
Prairie Dreams, 1989
Prairie Skies, 1993
The Sacred Earth, 1991
The Pilgrim's Guide to The Sacred Earth (with Sherrill Miller), 1991
Spirit of the Land, 1994
Sacred Places in North America: A Journey into the Medicine Wheel, 1994
Visions of the Goddess (with Sherrill Miller), 1998
W.O. Mitchell Country, 1999
Emily Carr Country, 2001
Old Man on His Back (with Sharon Butala), 2002

A LITTLE HELP FROM MY FRIENDS

I wish to acknowledge Amplis Foto and Agfa Canada for your generous support, Daymen Photo for your Lowe Pro equipment and Nikon Canada for thirty years of unfailing service. Thank you to Ian Toews and Jason Britski at Film 291, for hosting me at the Crackingstone Peninsula, Rod and Caron Dubnick and family for their expert guiding, Doug Chisholm for touring me to Hunt Falls and other northern destinations, and Cliff Speer, Tim Jones, Peter Jonker and Stan Rowe for introducing me to the north, and the many others that steered me throughout the Province.

Thank you to John and David Cave for scanning and cleaning the original transparencies, Sherry Morris and illustrious staff at J & S Picture Frame Warehouse, and Dr. Bob Kavanagh, Dr. Barry Brown, Glen Grambo and Dennis Fast for guidance into the complex world of digital technology. Thank you to Dennis Johnson for your vision and verve and to Erin Woodward and the rest of the extraordinary crew at Red Deer Press, and finally, to my partner Sherrill Miller for her role too large to define. What a team!

FRONT COVER: HARVESTING ON THE RAY MILNE FARM IN THE WOODLAWN DISTRICT NEAR DELISLE.
BACK COVER: MORNING LIGHT IN THE MEADOW AT OUR HOME NEAR GRANDORA.

PUBLISHED BY
Red Deer Press
2500 University Drive N.W.
Trailer C
Calgary Alberta Canada T2N 1N4
www.reddeerpress.com

CREDITS
Edited for the Press by Dennis Johnson
Cover and text design by Erin Woodward
Printed and bound in Canada by Friesens for Red Deer Press

ACKNOWLEDGMENTS
Financial support provided by the Canada Council, the Government of Canada through the Book Publishing Industry Development Program (BPIDP) and the Alberta Foundation for the Arts, a beneficiary of the Lottery Fund of the Government of Alberta.

NATIONAL LIBRARY OF CANADA CATALOGUING IN PUBLICATION
Milne, Courtney, 1943–
Saskatchewan : the luminous landscape / Courtney Milne.
ISBN 0-88995-327-9
1. Saskatchewan--Pictorial works. I. Title.
FC3512.M54 2005 971.24'04'0222 C2005-902313-9

For all of you who proudly call
Saskatchewan your home

"The real voyage of discovery consists not in seeking new landscapes but in having new eyes."

–Marcel Proust

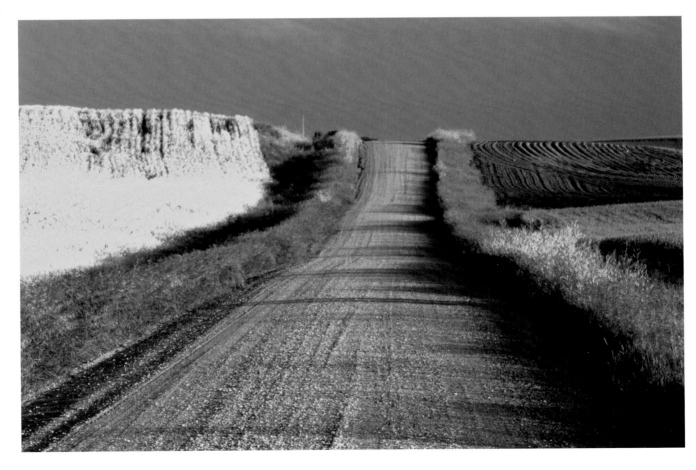

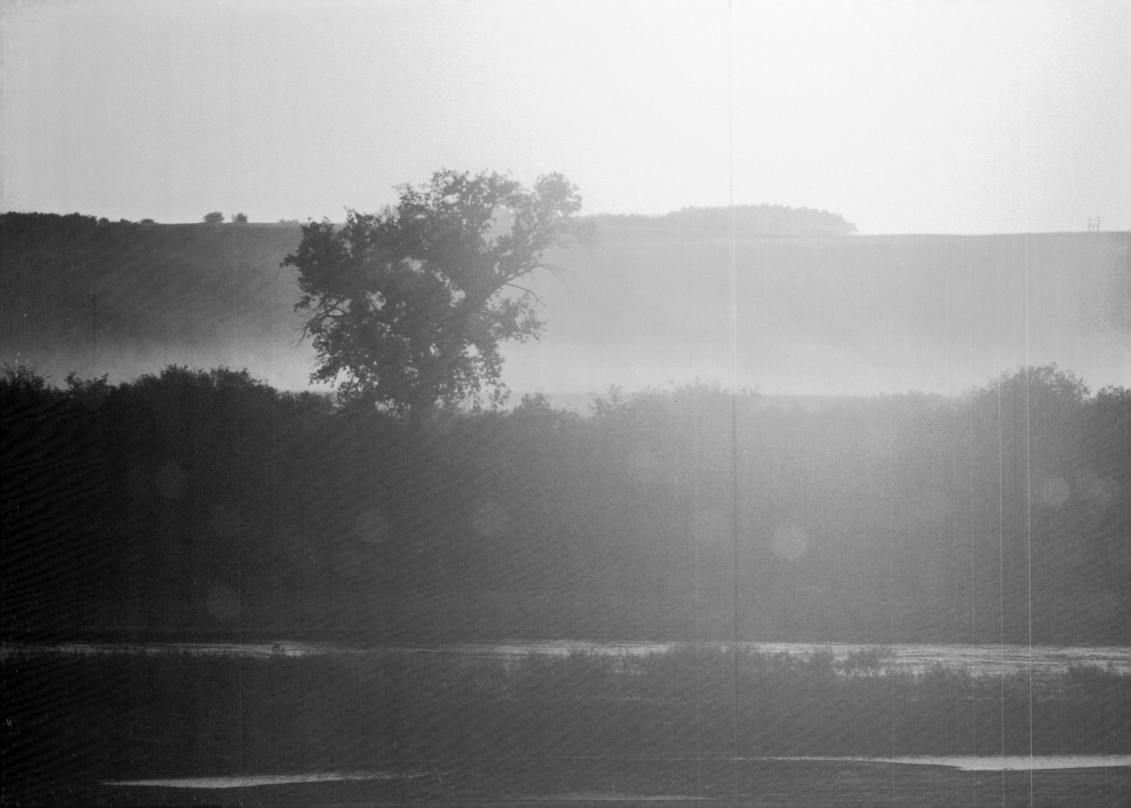

CONTENTS

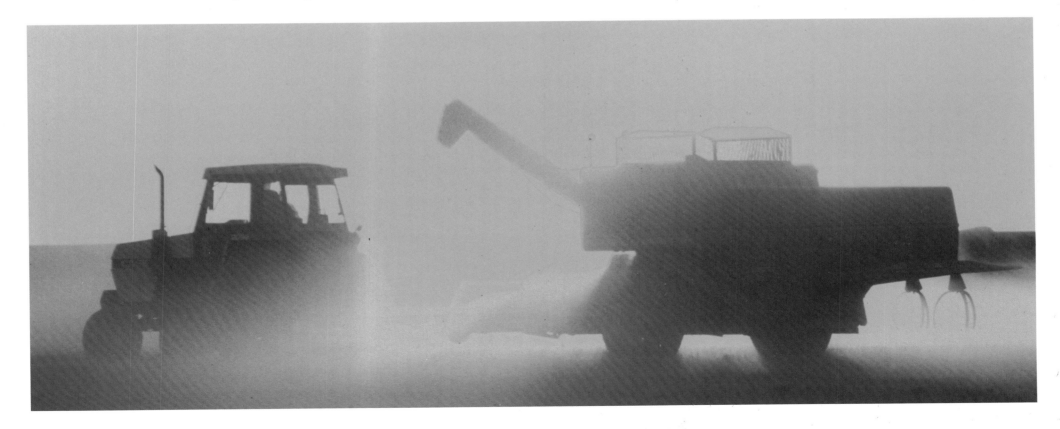

5

A MESSAGE FROM THE LIEUTENANT GOVERNOR

These are my history
the story of myself
for I am the land
and the land has become me
Al Purdy, "Man Without a Country"

Courtney Milne has captured images from many lands . . . from the heartland of the Aboriginal Dreamtime in Australia to the ancient stone rings of Britain. But in this collection, he returns home.

Saskatchewan is an awe-inspiring place—half of its 652,000 km² consists of forests, there are over one hundred thousand lakes, the northern zone rests on Precambrian rock, the Athabasca sand dunes are thirty metres high, and there are four mighty rivers.

The people of our one hundred year-old province have been defined by their relationships with the land, by the expansiveness of our sky, and by the kind of individualism that stems from surviving our strange dance with the elements. In *Saskatchewan: The Luminous Landscape,* Courtney Milne explores the beauty—subtle and spectacular—that surrounds and shapes us.

Milne's breathtaking photographs awaken a renewed appreciation for this extraordinary corner of the globe. Like Emily Carr, he investigates the spirit rather than simply the physical reality of nature. Like the impressionists, light becomes not merely an effect in his work, but the subject. Every sound, every smell, every texture, every hue is gifted to us on these pages. What a wonderful tribute to this beloved land.

Lynda Haverstock

Her Honour Dr. Lynda Haverstock

A MESSAGE FROM THE PREMIER OF SASKATCHEWAN

On behalf of the Government of Saskatchewan, I am pleased to welcome readers to *Saskatchewan: The Luminous Landscape.*

This, Saskatchewan's centennial year, is a most auspicious time to publish *Saskatchewan: The Luminous Landscape.* We have beauty overhead and around us, and we have rich resources under our feet. We have fertile farmlands, bountiful forests, advanced technology, a growing manufacturing sector and an ever-increasing number of value-added enterprises. This collection of gorgeous photographs once again demonstrates Courtney Milne's love of this land and keen eye for striking images.

I congratulate Mr. Milne for producing this stunning visual contribution to our centennial celebrations. I wish him, and you, the reader, a centennial year filled with good health, happiness and celebration.

Lorne Calvert
Premier

PREMIER OF SASKATCHEWAN

LEGISLATIVE BUILDING

REGINA, CANADA S4S 0B3

MUSINGS AND MEANDERINGS
recapturing childhood

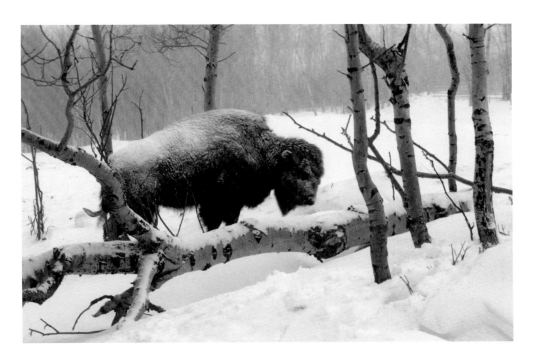

The story of my life is the story of my photography—particularly of my penchant for luminous landscapes.

I was blessed to be born in the heart of such a landscape—in fact, in the centre of Saskatoon. Growing up on the bank of the South Saskatchewan River, I spent a joyous boyhood out of doors, hanging out with my father, a farm equipment dealer. Many moments are locked in memory from that time, but the most poignant are those of gazing at outrageously glorious sunsets, the western sky exploding for me with the same kind of excitement as the fireworks at the Exhibition.

Though I trained in photography, my early working life was not in the fine arts, but in executive work. Day by day, month by month, I felt myself sinking deeper and deeper into a sea of desolation. In December 1974, following this period of severe stress, I received a preliminary diagnosis of diabetes, and I found myself wandering the same river that had stirred me as a child. But now it was night, and I ambled aimlessly along its bank with a shattered will and a broken heart.

At 6:00 A.M., the restaurant in the bus depot opened. I slipped inside, escaping from the punishing cold. Sitting alone, staring into my reflection amidst the snow swirling outside the window, an unfamiliar voice, distinct and authoritative, broke my reverie: "If you want to survive, you will leave your job, move into a shack on the edge of Saskatoon, and you will photograph bison and northern lights."

I had nothing to lose. If the voice was an epiphany, if it was true, I would follow it back onto the land, the source of so much happiness in my youth. I got up from the table and that same day composed my letter of resignation, even though I had no idea of how I would survive. I gave notice to my landlord and within weeks had moved to a tiny house with no heat or electricity. I slept on the linoleum floor, my sleeping bag wrapped around a small catalytic heater. Within these primitive surroundings, I found a place to call home, and—more importantly—I found both inspiration and peace. Shortly after the move, I received word that my blood sugar levels had returned to normal.

What has already been a thirty-year career had been launched. Within a few months, in response to that inner voice, I was photographing a bison herd on a ranch near Hepburn, their hooves stomping the snow, their breath steaming in the frozen air. Successfully photographing the shimmering dance of the northern lights, more technically challenging, took longer.

This chapter is a scrapbook of some of my more memorable outings to the south of the province, the place of my childhood. Each image speaks to me of shining youth, when the play of light throughout the day and the seasons reminds me that the world is forever new if we are attuned to it.

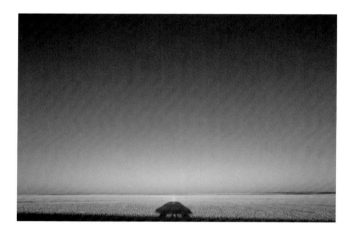 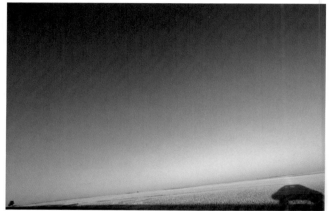 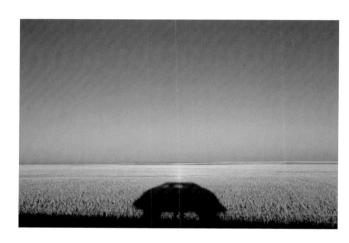

Just over a hill, north of Swift Current, a lone poplar tree grows beside the highway. It has affectionately been dubbed the Swift Current National Forest. When I drive past, I always toot my horn, but today the clear sky and warm evening light invite me to pause. As I reach for my tripod, I become fascinated with the light around the shadows cast by me and my car.

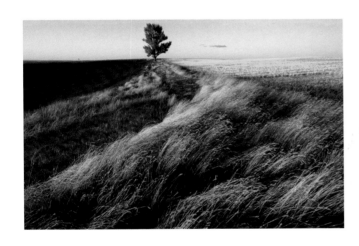 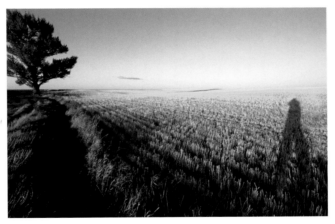 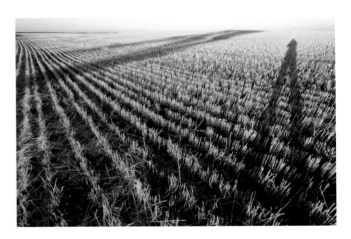

The landscape, flat and textured, offers a magnificent stage on which to play with scale and geometry. It reduces all to bare essentials: the field, the tree and me, our shadows growing toward infinity.

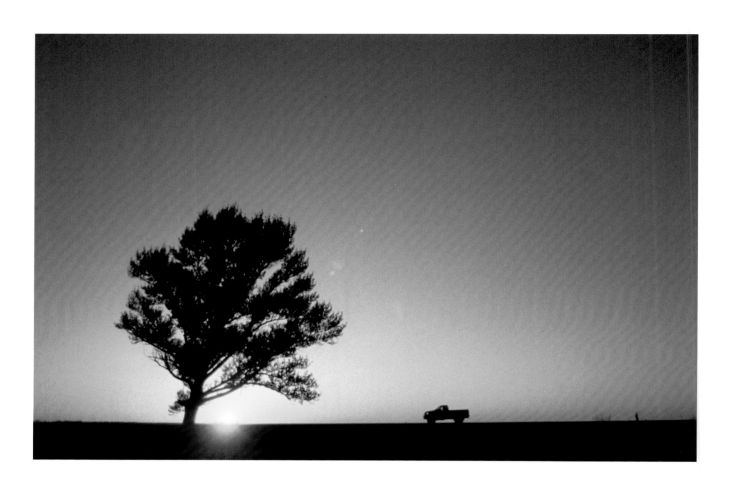

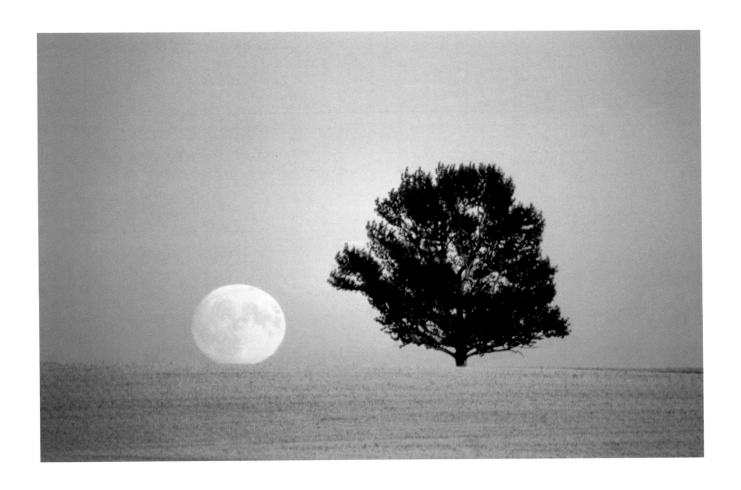

As the sun touches the horizon, my shadow grows to infinite size, then disappears. I stride to the east, line up the tree and the sun, and enjoy the dramatic contrasts found at last light. I remember how, twenty years earlier, I had caught the first glimmer of moonrise on this same enduring tree.

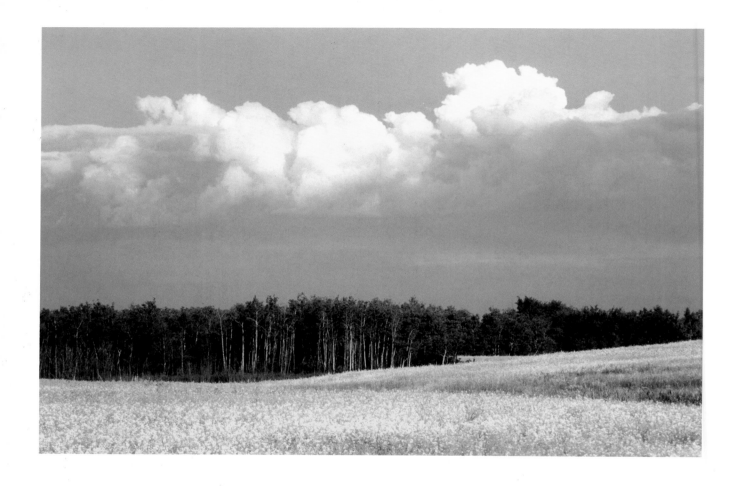

Northeast of Saskatoon lies some of the loveliest farming country in Saskatchewan. In June, the whole world takes on an effervescent green. Everywhere, the quality of light on the new crops reminds me of the irresistible temptation I felt as a youth to play hooky in those first warm days of spring when life was bursting from the land.

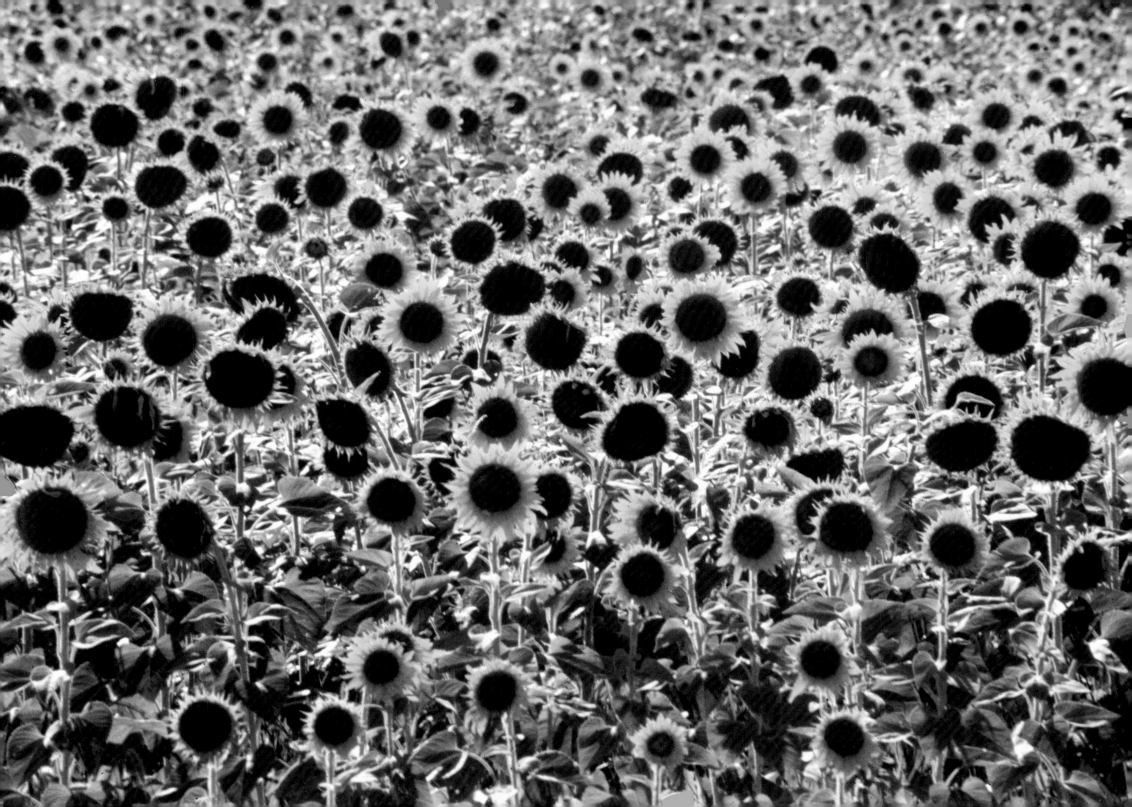

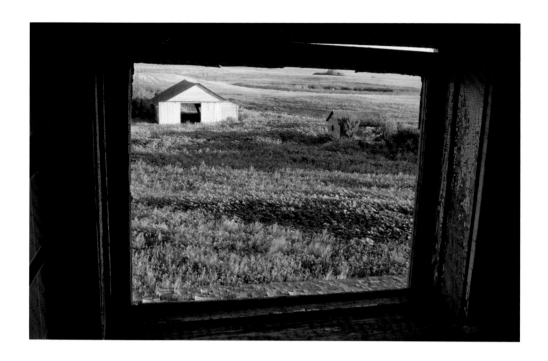

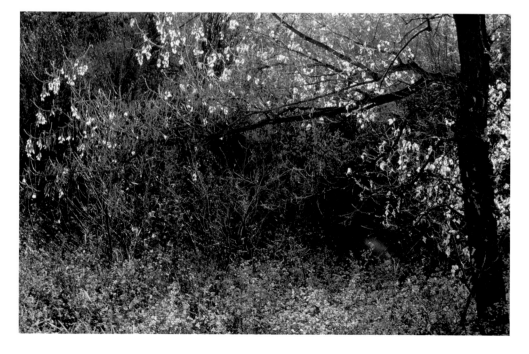

What do the upstairs window of a derelict farmhouse near Southey, autumn at Wanuskewin, a spider web at Good Spirit Lake and Kiwanis Park in Saskatoon have in common? Answer: They are all a celebration of light on landscape and a reminder that nature's artistry is everywhere in vistas both large and small.

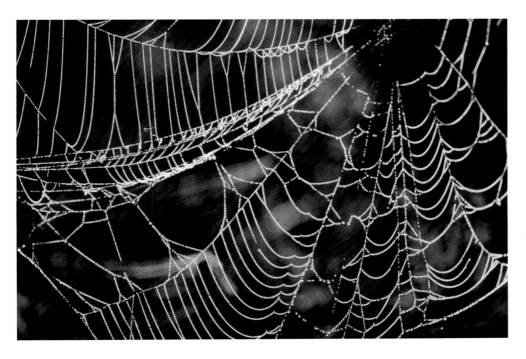

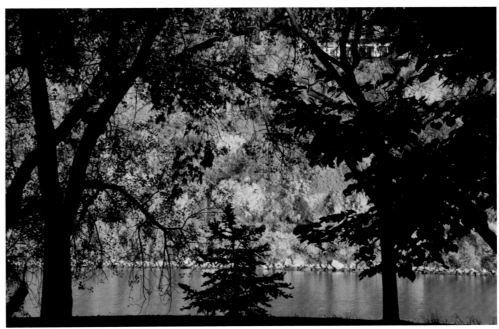

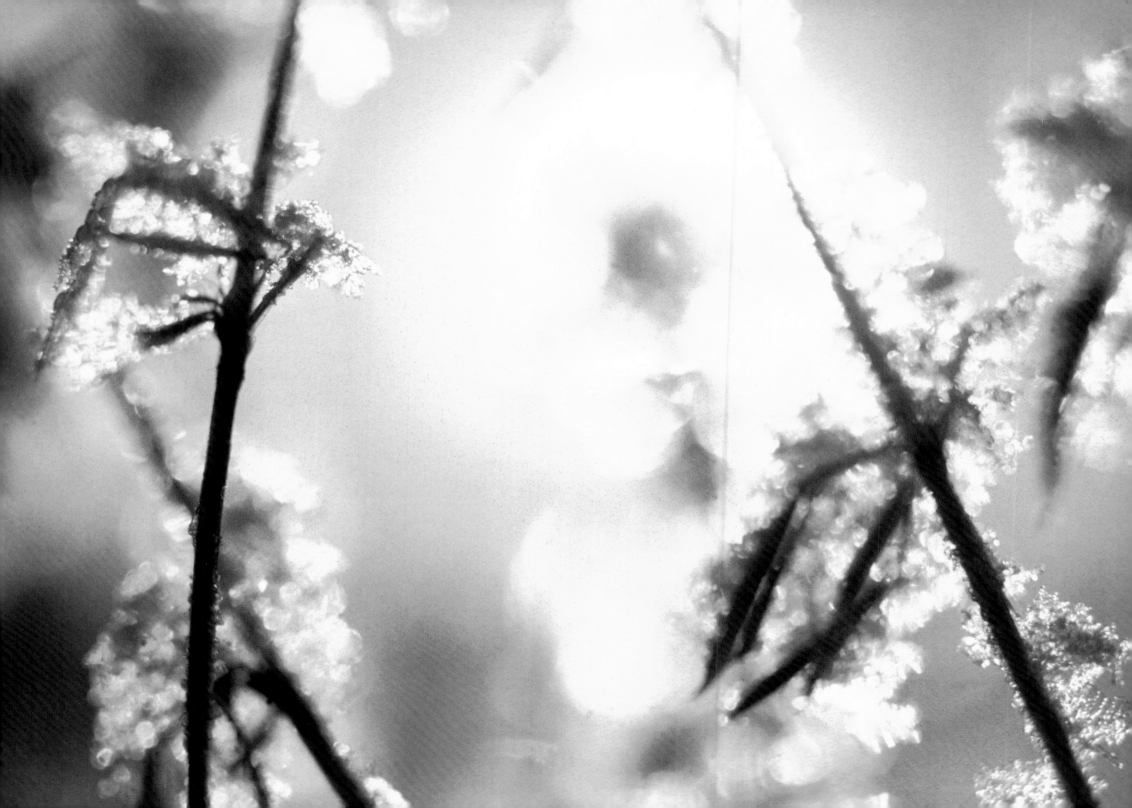

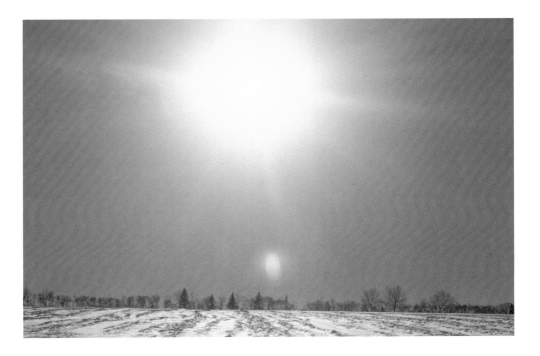

Even the coldest days of the year are an invitation to photograph, at least until my camera batteries or toes freeze up. Today, I take my Melfort photo class on a downtown fieldtrip and assign them to compose images of cars, exhaust and buildings. One woman, not dressed for the severe wind chill, says she "can feel the exhaustion but can't get composed." What better way to describe such a wintry scene?

 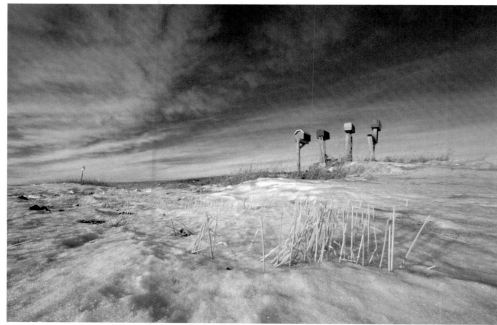

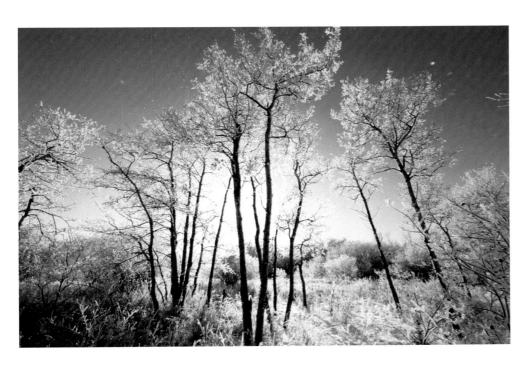 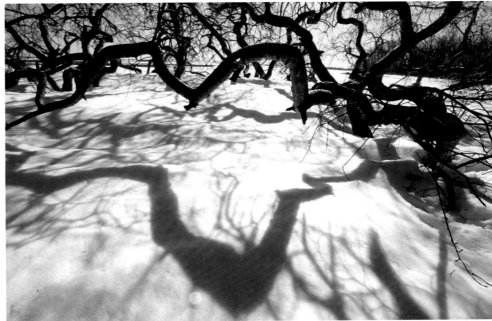

Sometimes when I photograph trees, they remind me of growing up, especially our formative years. Some grow straight and tall, seeming to reach effortlessly for the sun. Others, like the crooked bush near Hafford, become inexplicably gnarled, their shadows hinting at a story of struggle.

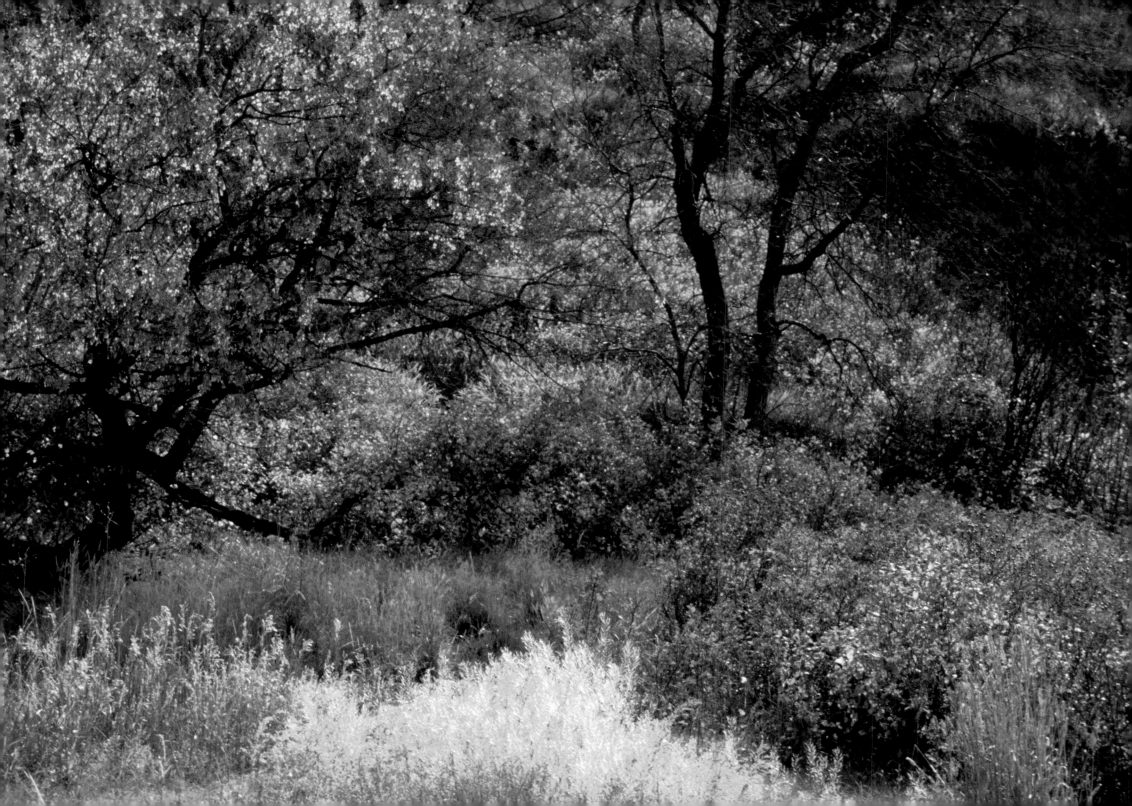

◀ Meanderings are not just a geographic journey, but also an opportunity to witness seasonal changes. At Wood Mountain, early spring rains spur growth among dead grasses and bushes, offering subtle patterns of contrast that link the seasons in harmony.

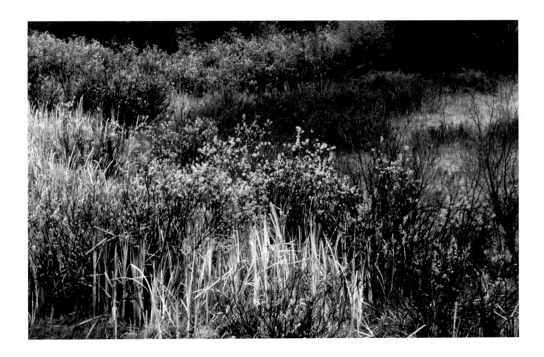

▶ The Qu'Appelle Valley finds her greatest radiance dressed in autumn finery. "Who calls?" the legend asks, and I want to answer by reaching out to the mystery of the valley.

23

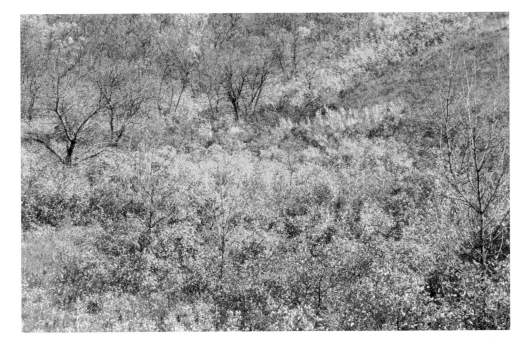

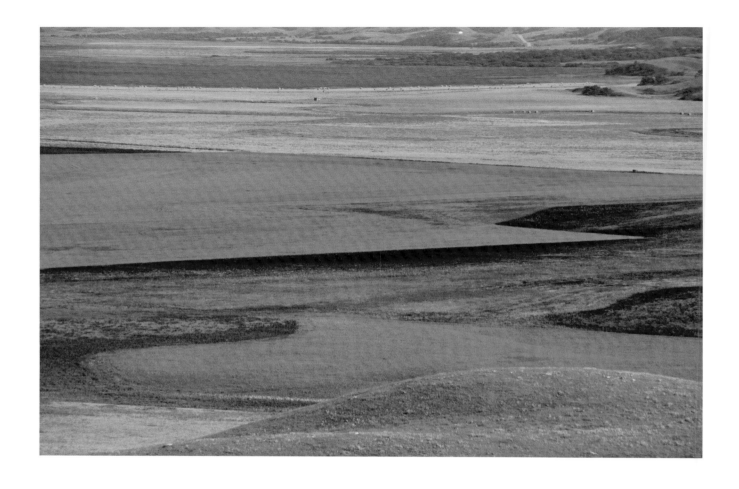

Summer colours in the Qu'Appelle Valley.

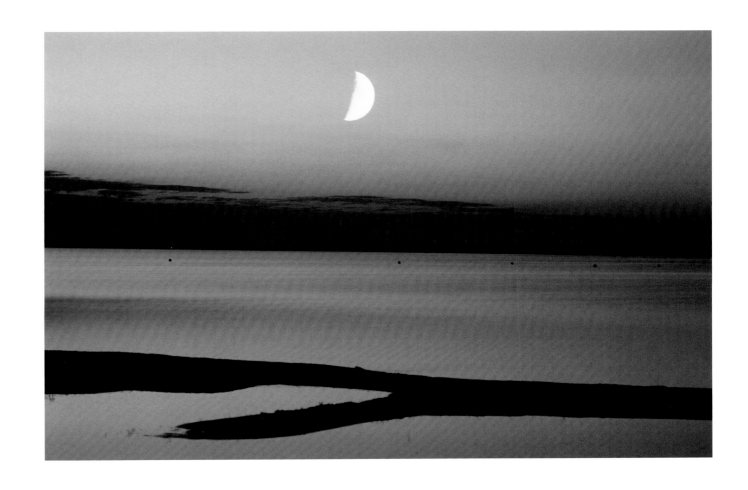

July colours on Good Spirit Lake.

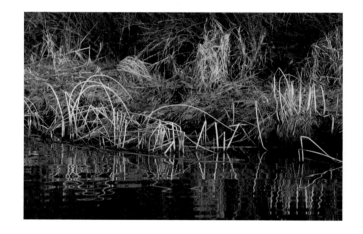 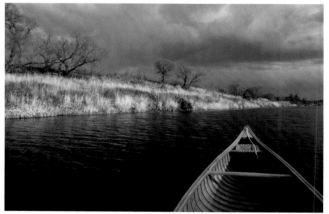 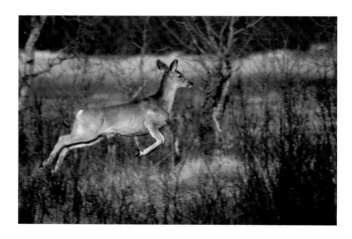

Inspired by Connie Kaldor's epic song "Wood River," I set out on the Wood River by canoe to see whether "the heart is bigger than trouble, the heart is bigger than doubt." Maybe so, but one doubt that lingers is whether I can get anywhere on the creek when every turn beckons me to pause to capture another scene. Because the Wood River continually meanderers, by the end of a long day on the water, I have only a ten-minute walk as the crow flies back to my camper! Such a day makes our usual definition of progress irrelevant and confirms that getting somewhere slowly can be infinitely more satisfying than getting nowhere fast.

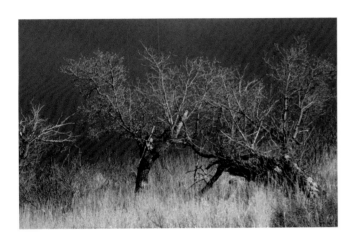 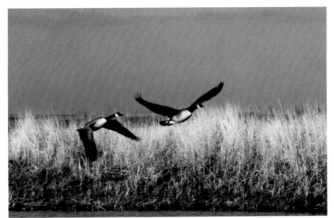 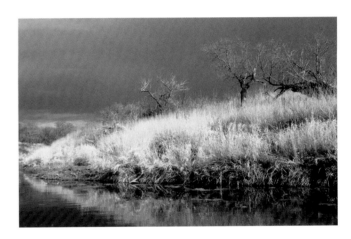

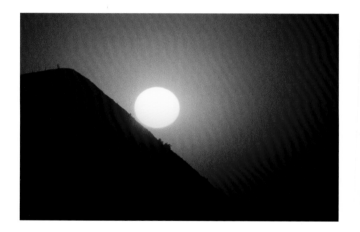 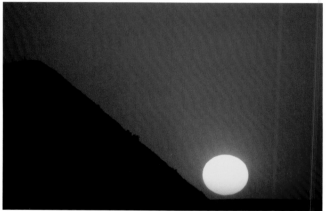 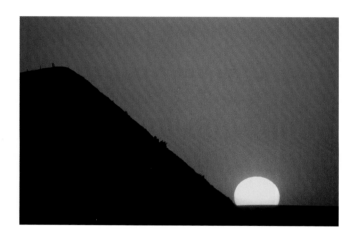

Today, I explore Castle Butte in the heart of the Big Muddy. Forest fire smoke has drifted from the north, turning the sky to deep ruby through which a jewel-like golden sun makes its passage toward night.

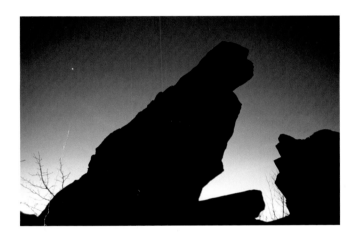 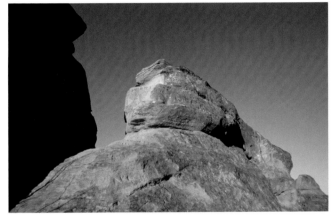 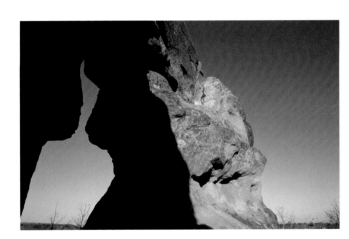

My first trip to Roche Percé finds me at the stone formations
before first light. From a clear sky with stars and silhouetted
forms, subtle details begin to reveal themselves in the brilliant
light of dawn.

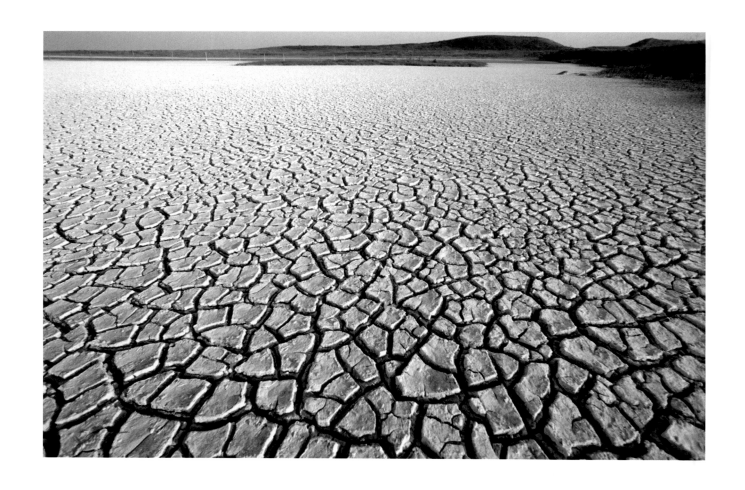

Mud cracks on Big Muddy Lake.

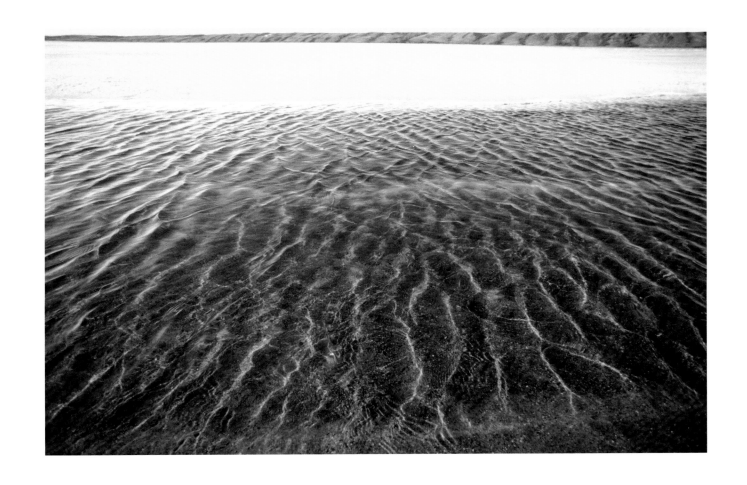

Today marks my first return to Lake Manitou since age ten. I arrive to find it wearing its white winter mantle, but the southern shoreline has succumbed to the promptings of a warm April sun.

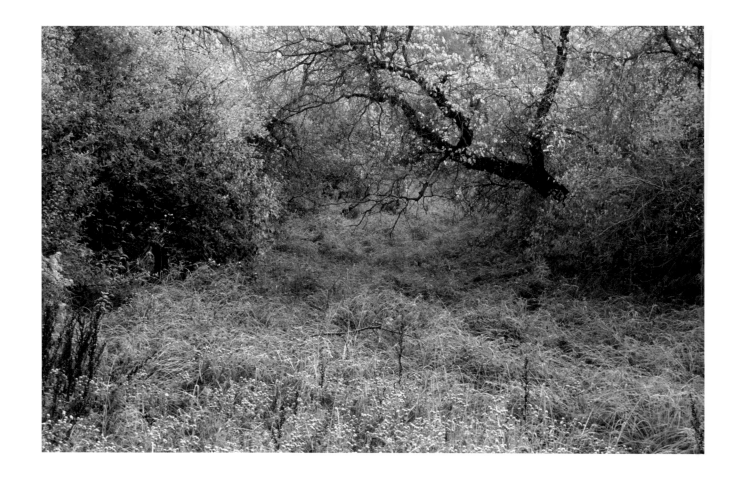

32

Wanuskewin, on the north bank of the South Saskatchewan River, was a place of healing, hunting and celebration for First Nations people thousands of years before Saskatoon, its sister settlement, grew up beside it. Now people from many backgrounds converge at Wanuskewin, aspiring to "see nature with the eyes of an eagle."

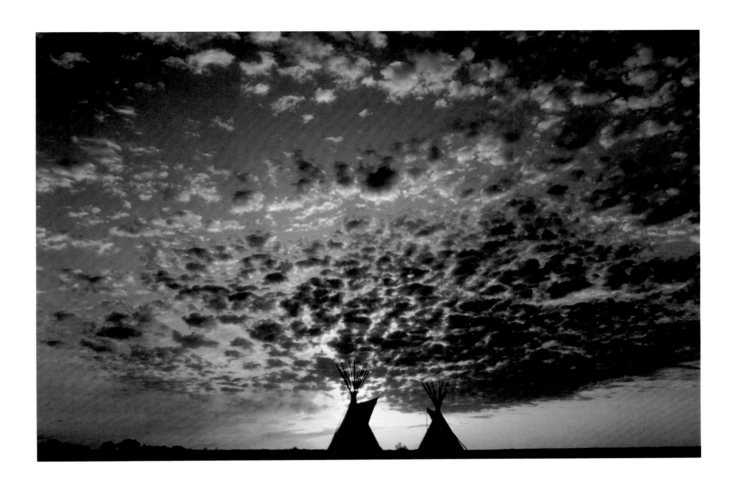

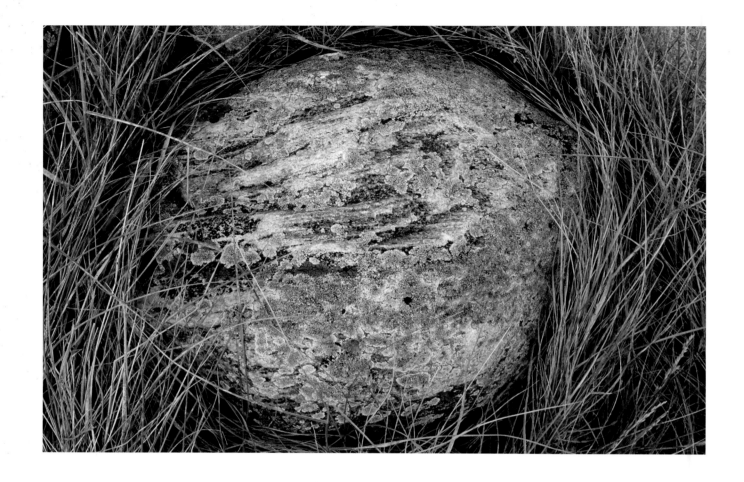

A favourite pastime of mine is to pack a lunch, camera and tripod, and get lost in the hills. Among them are scattered hundreds of treasures in the form of lichen-covered rocks nestled in the tall grasses of the Roy Rivers Medicine Wheel. So close to the Alberta border is this height of land that both the town of Empress and the confluence of the South Saskatchewan and Red Deer rivers can be seen from the summit.

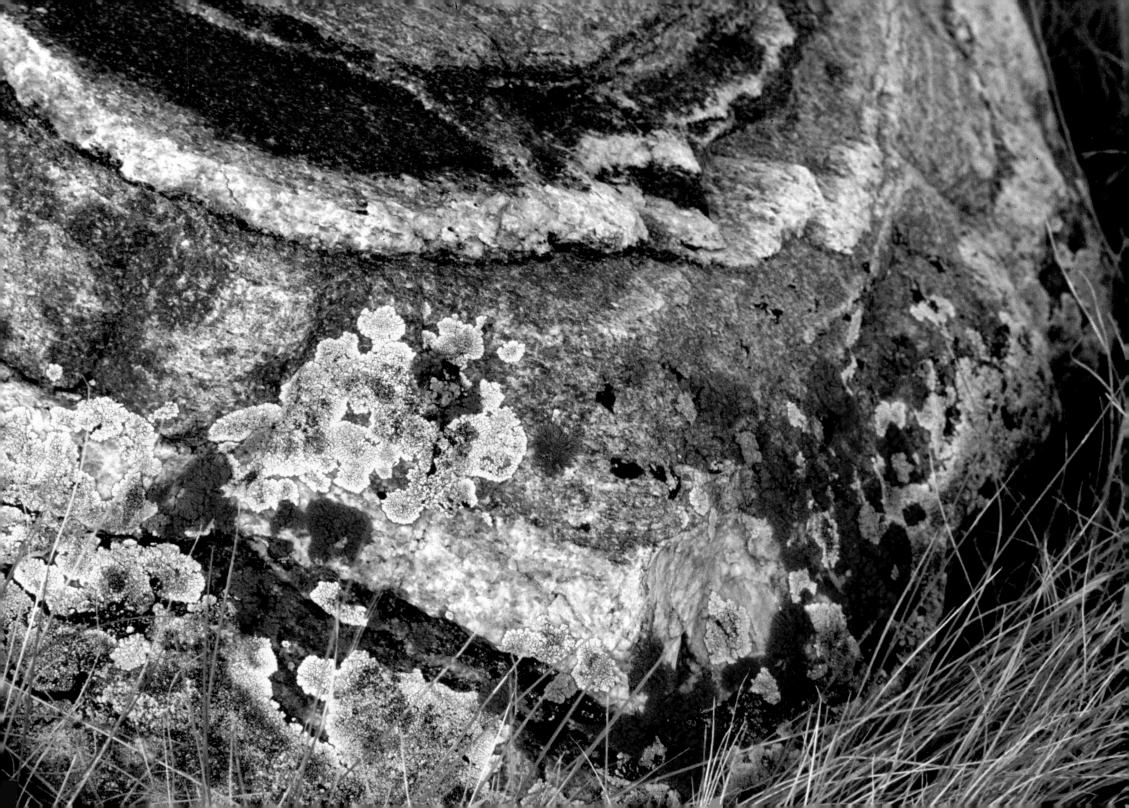

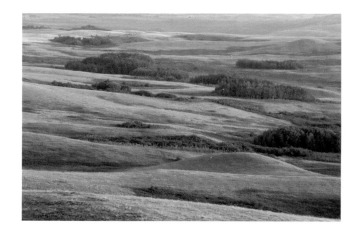 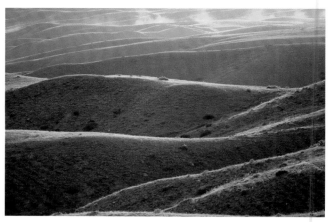 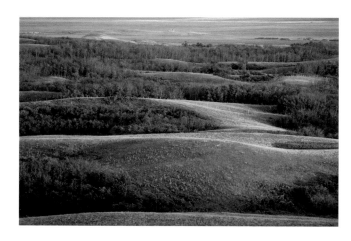

In many of Saskatchewan's hills, First Nations people made their medicine wheels and there found personal guidance through vision quests. From left: Eagle Hills, northwest of Biggar; view from Roy Rivers (Empress) Medicine Wheel; view from Moose Mountain Medicine Wheel, near Carlyle.

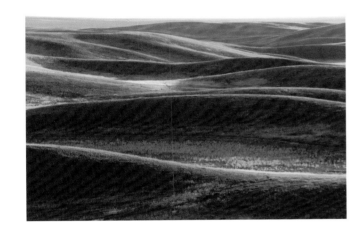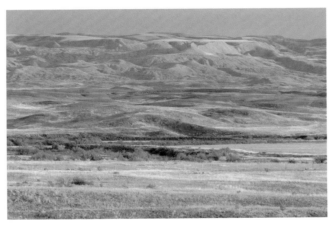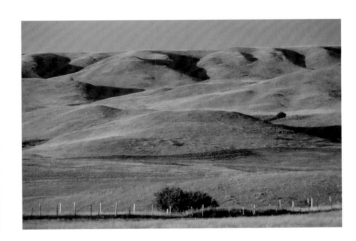

From left: Old Man on His Back, west of Claydon; Grasslands
National Park; The Bench, south of Tompkins.

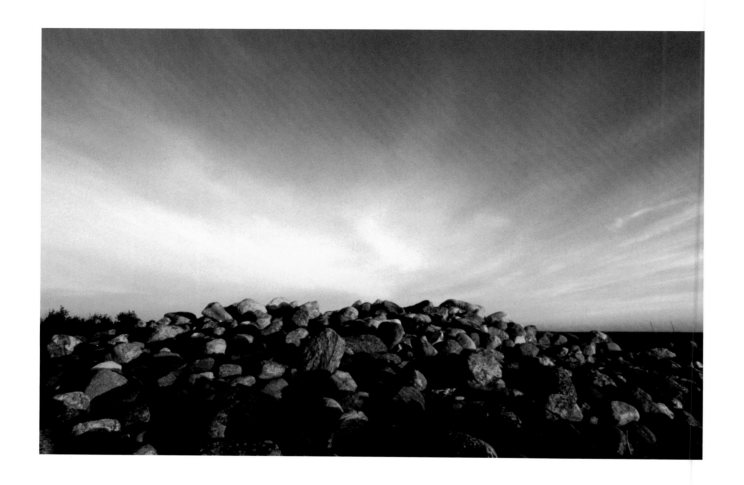

38

Members of the Pheasant Rump Band are the present-day guardians of the Moose Mountain Medicine Wheel. Washed by the last rays of the setting sun, the central cairn glows as if proud of the secrets it contains and the history it has witnessed.

BOREAL AND BOREALIS
ventures into the North

Boreal and borealis—even the words (both meaning north) conjure images of a wild, untamed land shrouded in the mystery of the aurora borealis. Aurora is the Roman Goddess of the Dawn, and Boreas, the Greek God of the North Wind.

My experiences in the boreal landscape began when I was seven or eight years old when, during short summer vacations to Waskesiu, we would watch a mother black bear and her two frisky cubs at the "nuisance grounds." I thought the garbage dump was called that because the bears were such a nuisance as they rummaged through bags of garbage. Their antics were the highlight of my summer.

In my teen years, the North meant summer scout camps at South Bay on Waskesiu Lake, where it seemed there were as many bears roaming through our campsite as there were humans learning to coexist with them. One night, we appropriated a gallon container of strawberry jam for a midnight snack in our tent and woke the next morning to find the empty can outside our tent flap! I don't think one of my fellow scouts consumed the rest of the contents during the night.

In my university days, I was introduced to canoeing in the North, and I was hooked right from the start. In a canoe, I finally felt as though I was genuinely part of nature. I learned to "Indian paddle," moving in silence so I could stalk beaver and muskrat. I spent countless sun-filled hours drifting in stillness down the North Saskatchewan or floating lazily on the Churchill, time during which the North was teaching me how to sense its mysteries.

It wasn't until after travelling through much of the world that I had the opportunity to visit Hickson Lake and its sacred red ochre rock paintings. By then, I was seeing the North through seasoned eyes and comparing Saskatchewan's sacred landscapes with those of other cultures. Then, in 2004, I finally visited Saskatchewan's highest waterfall, Hunt Falls on the Grease River, and I fell in love all over again with Saskatchewan's northern rivers and its hundred thousand lakes, many of which have never been fished. These constitute an enormous privilege as well as a tremendous responsibility. We must preserve our wild and sacred places, where the timeless rhythms of nature go on untouched by humans.

Those who have shared my Soul of the Camera workshops at the Emma Lake Kenderdine Art Camp know the power of being immersed in a pristine landscape for an entire week. Gradually, the habitual blinders to pure seeing fall away, and Aurora allows us a glimpse of her most intimate treasures, especially in the mists of dawn.

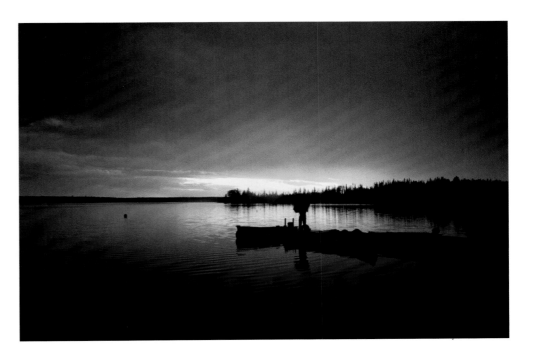

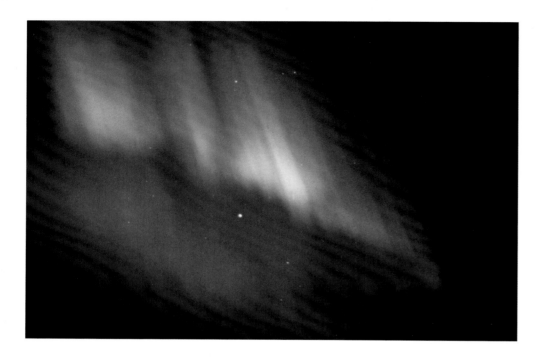

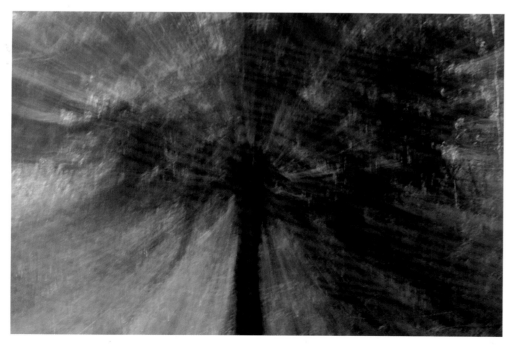

Aurora is the Goddess of the Dawn, but she is also the Queen of the Night Skies. The big-name stars like Polaris and the Little Dipper attract many fans, but when Aurora takes to the night stage, she always steals the show.

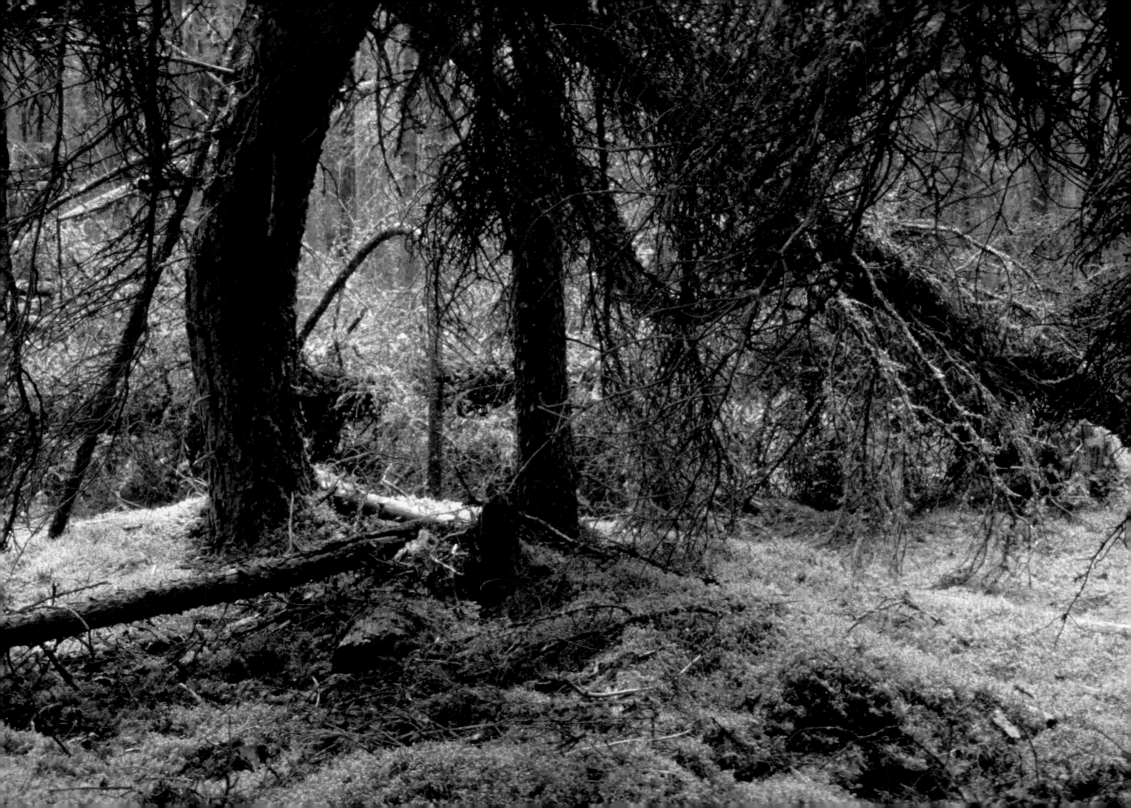

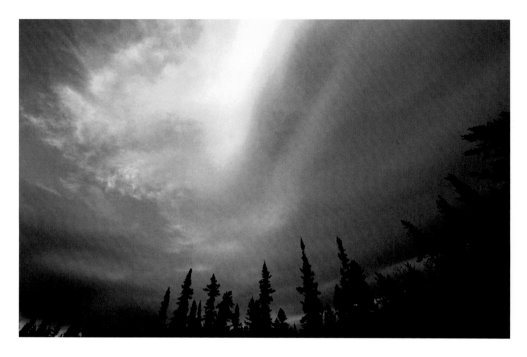

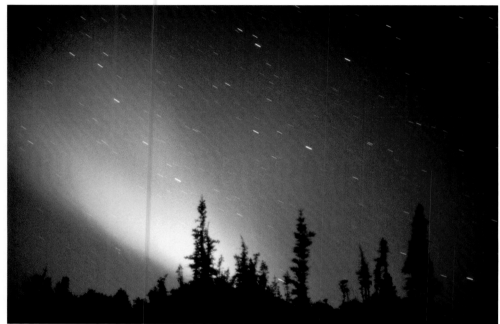

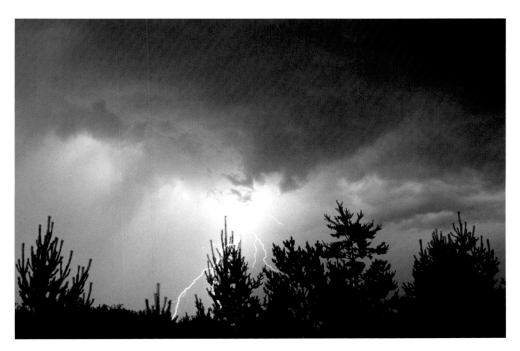 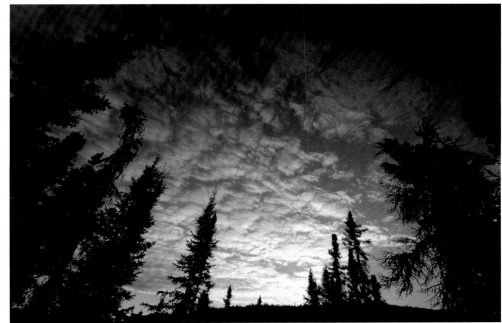

Much of Northern Saskatchewan, from Prince Albert to the higher latitudes, is covered in forest punctuated by lakes covering as much area as the land. Once you are past the popular resorts, prepare for solitude.

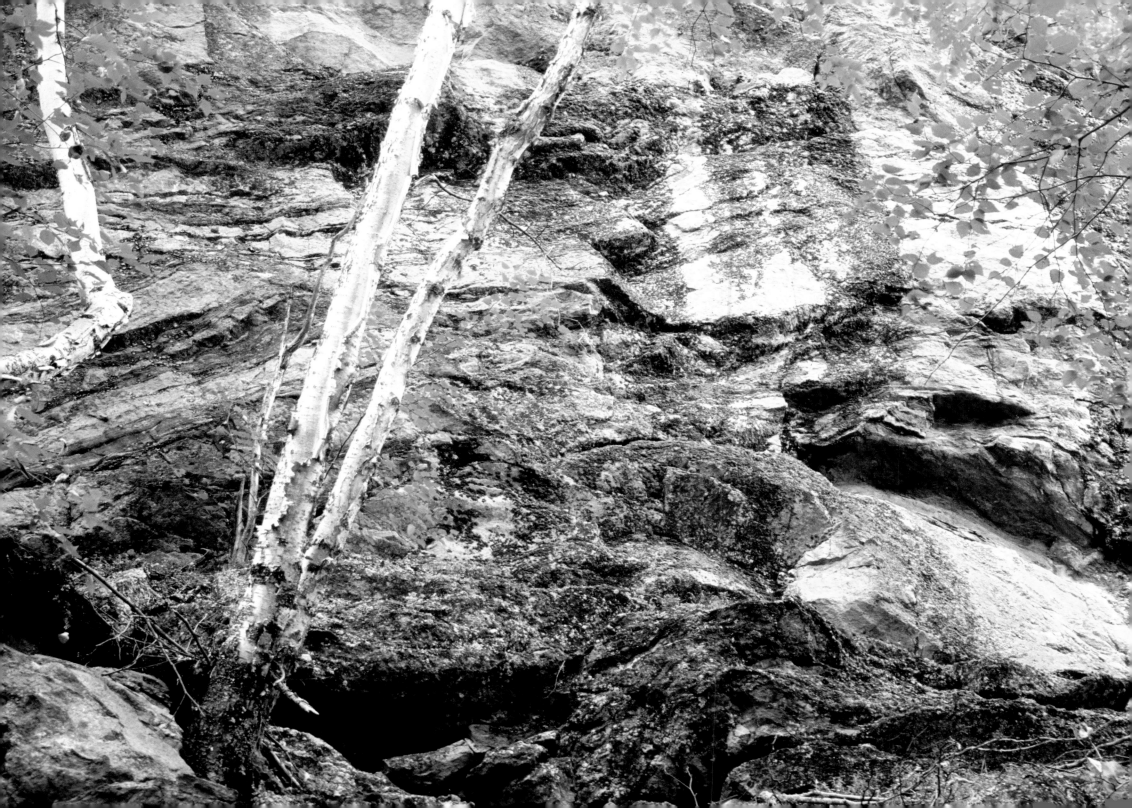

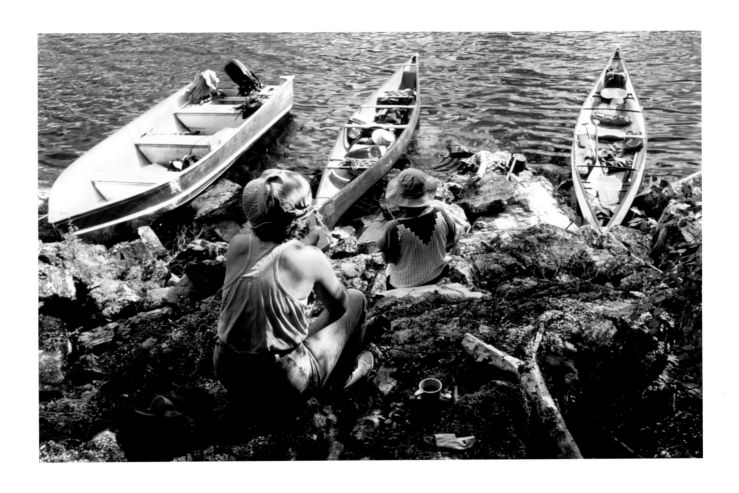

Journal entry: "Sunday, August 8, 1997: Today, we followed the shoreline of Hickson Lake with the outboard and two canoes. After being wind-bound yesterday, we were all a bit giddy in the warm sunshine and sparkling water. At our lunch spot, the birch glowed with radiant light."

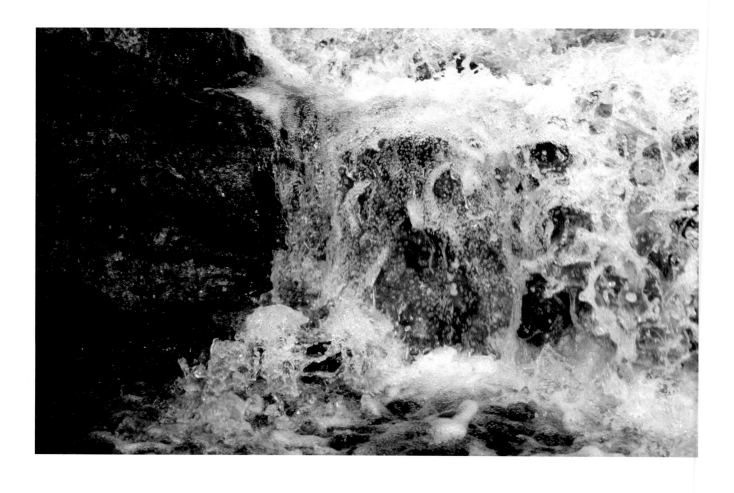

Journal entry: "September 2, 2004: Touched down on Eagle Rock Lake above Hunt Falls and pitched camp. Doug showed me the path to the falls, then took off in his floatplane. As the roar of the aircraft's engine receded in the distance, I found myself in an overpowering stillness broken only by the muffled thunder of the falls below."

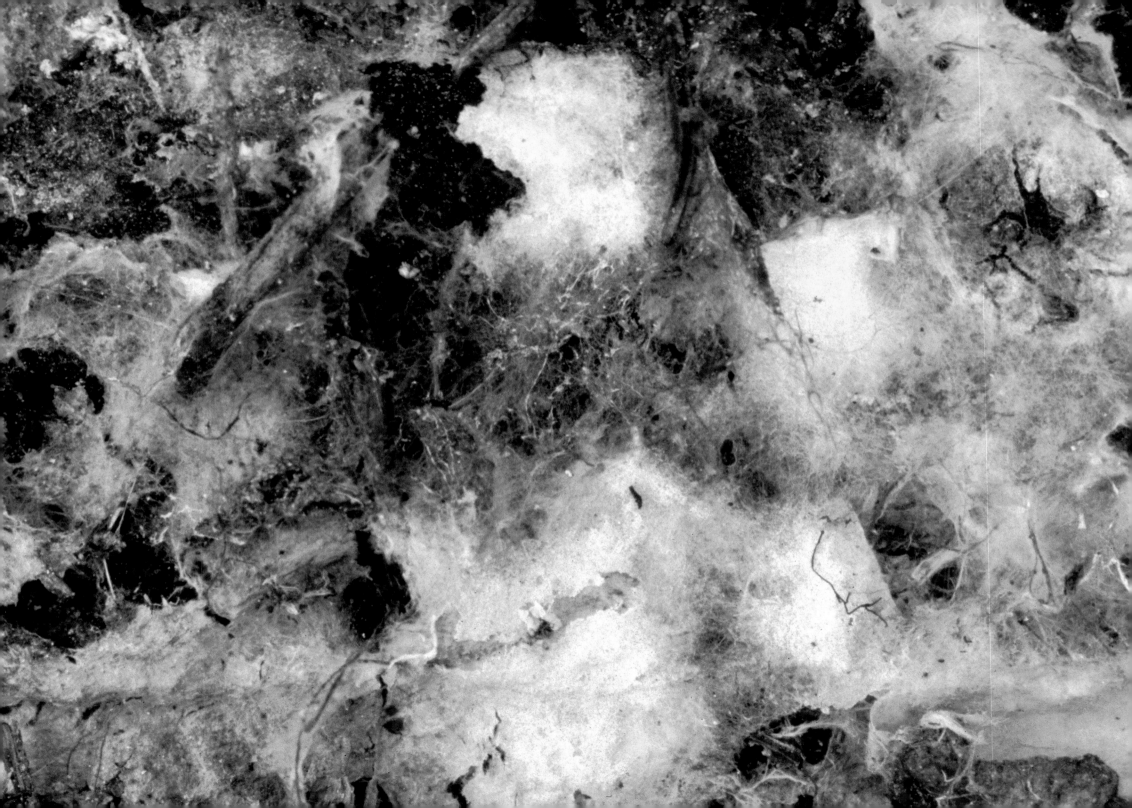

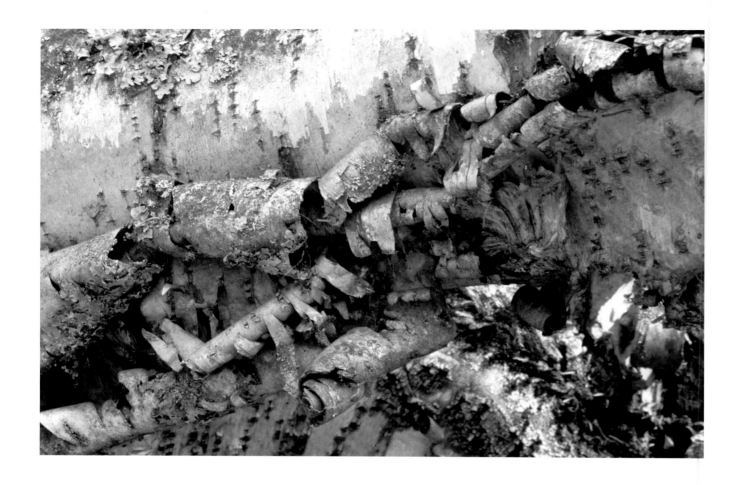

I pray for overcast skies when I photograph micro landscapes at Emma Lake. The softer, multi-directional light causes a fallen birch and lichen to radiate with a luminous glow that almost seems to come from within.

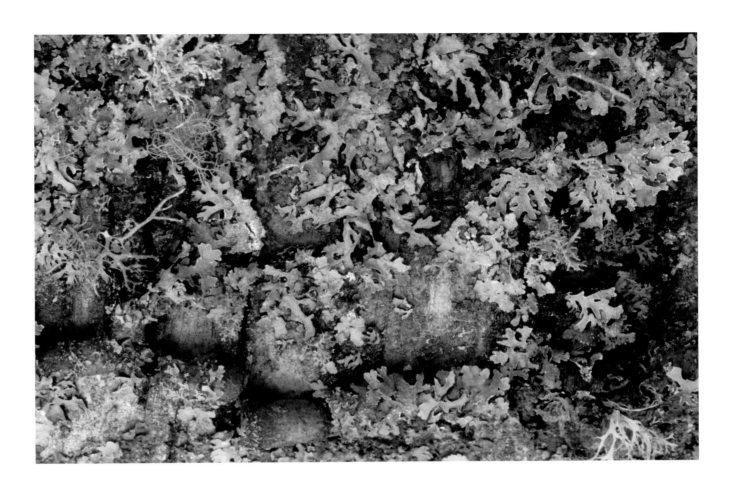

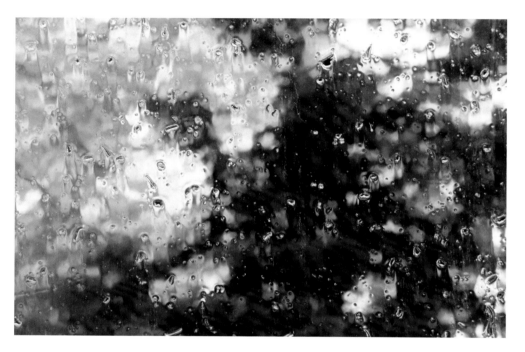

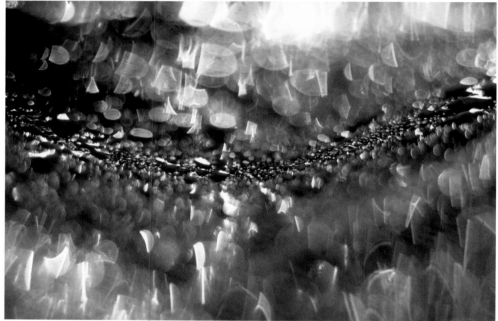

I wake to the patter of rain falling on the skylight above and reach not for coffee, but for my camera. A great feeling to have the day's work done before getting out of bed! After a rain is the time to explore water droplets on leaves. Peering along the edge of the leaf through a macro lens is an invitation to capture the unseen.

The University of Saskatchewan can be justifiably proud of its
Kenderdine Campus at Murray Point on Emma Lake. The
artist-in-residence program gives me the opportunity to explore
to my heart's content, and I am frequently swept up in patterns
of shape and colour and texture in the smallest of scenes on the
forest floor.

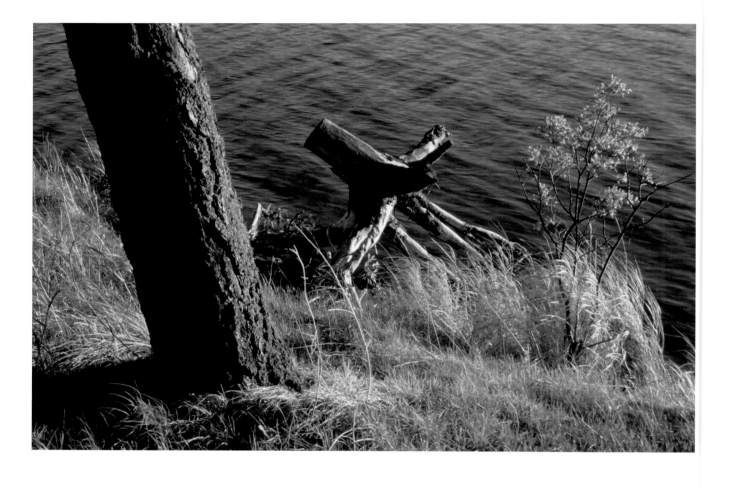

Heather Bishop excels when she sings acapella. I'm not sure if it is her voice or the message in her lyrics that moves me so profoundly: "Northland, you're young and you're wild and your spirit's still free; you've a chance to do it better than we've done it down here." In untouched wilderness, we experience a profound sense of the ebb and flow of events outside of human time. There, we can resolve "to do it better."

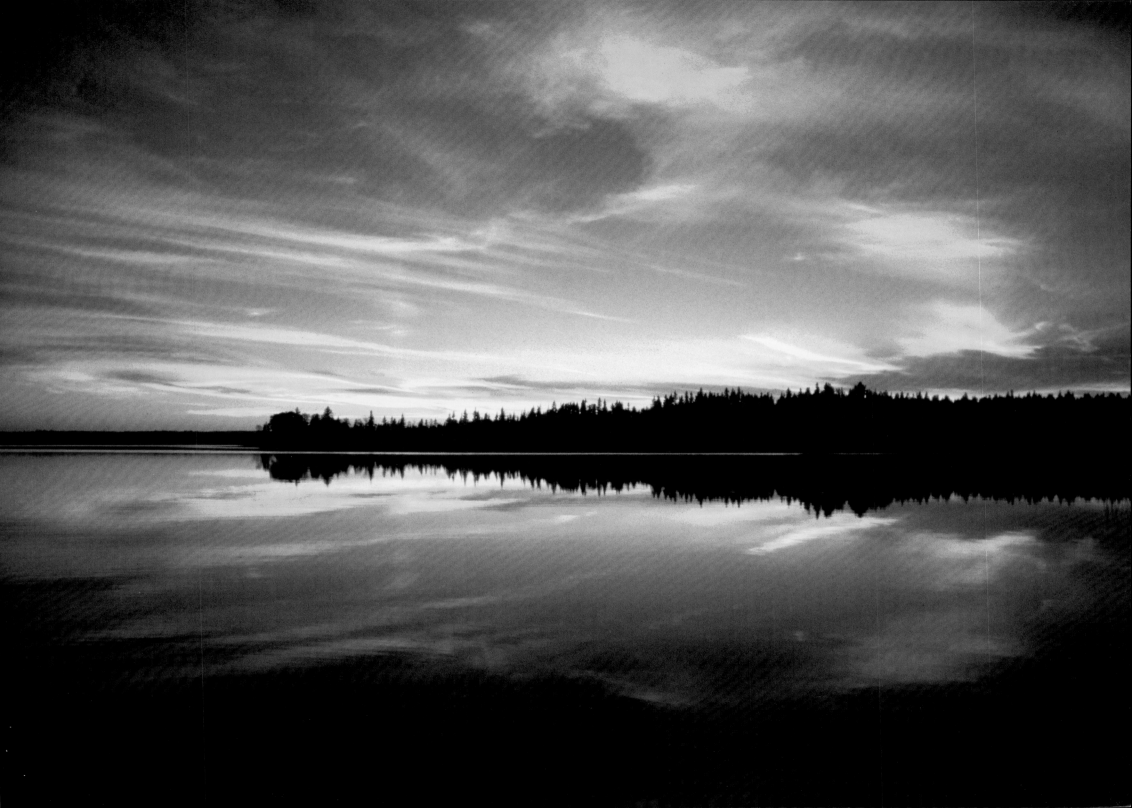

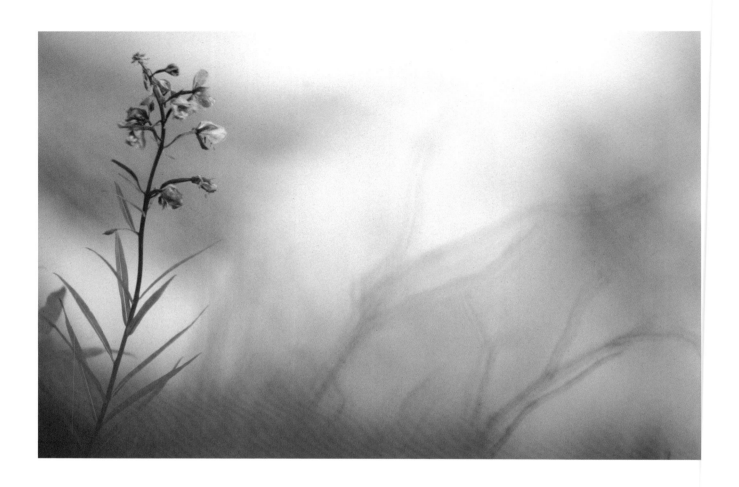

Fireweed at the edge of Hunt Falls.

ATHABASCA
sand, sea and rock

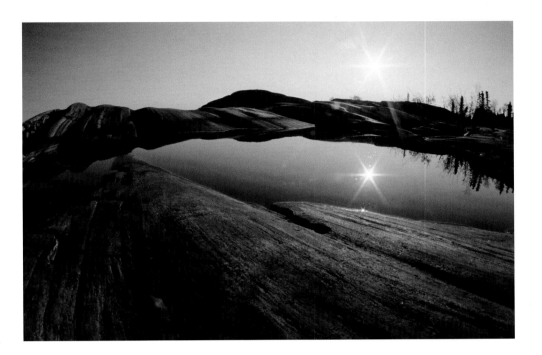

At a latitude above 59 degrees north, Lake Athabasca, more the scale of an inland sea than a lake, unites Alberta and Saskatchewan in a common basin. In years past, uranium brought people by the thousands to Athabasca's northern shore, but in 1982 the Eldorado Mine phased out its operation, and Uranium City is now little more than a ghost town.

My first trip to Athabasca country was a quest to photograph the northern lights; my second, to explore the dunes. The dunes stretch for more than one thousand kilometres along the south shore of the lake. Towering in places to heights of more than thirty metres, they are the world's largest area of active sand dunes north of 58 degrees latitude.

To spend a day walking this seemingly endless sea of sand is to lose oneself in a forgotten world, where time ceases to matter and schedules depend only on the natural rhythms of weather and light.

When I reached the top of the highest dune west of the William River and surveyed in all directions, I felt as though I was literally on another planet. "How easy it would be," I mused, "to get lost out here and how helpless one would quickly become without shade, water, food or shelter from the blowing sands." In Biblical times, to be exiled to the desert surely was a sentence of certain death.

This great sand sea is a metaphor for eternity. To be here is to feel in the pit of your stomach the great contradiction of endless space: in its expanse is the essence of freedom, yet that same limitlessness imprisons when you recognize you may never escape it alive. You both fall in love with and fear its boundless space. This land makes no distinctions, cuts no deals, regards you as neither friend nor foe. Here there is no give and take, no compromise. Here there is no escape from the haunting silence of the night, no retreat from personal demons.

The Athabasca dunes, it could be argued, are the most representative symbol of what it means to live in this province. They *are* Saskatchewan personified. To survive in the dunes is to learn to turn your back to the ceaseless wind, to turn your head from the merciless sun. But in teaching you to respect the elements, the dunes anchor an appreciation of wilderness that can't help but grow into a love of place few in the world feel so deeply and intimately.

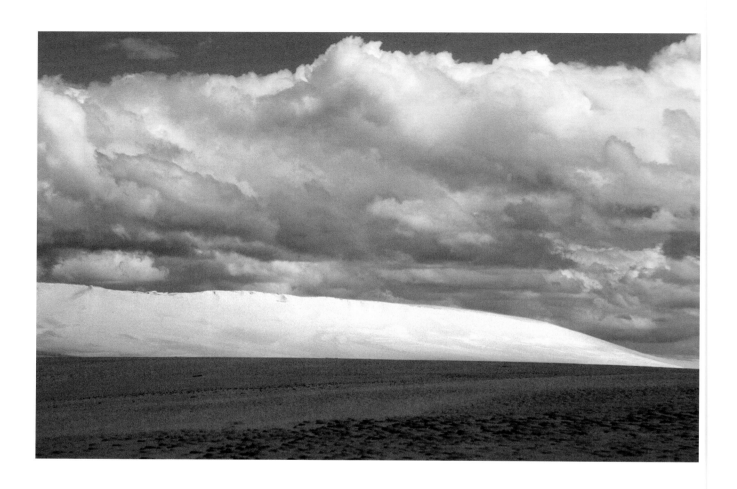

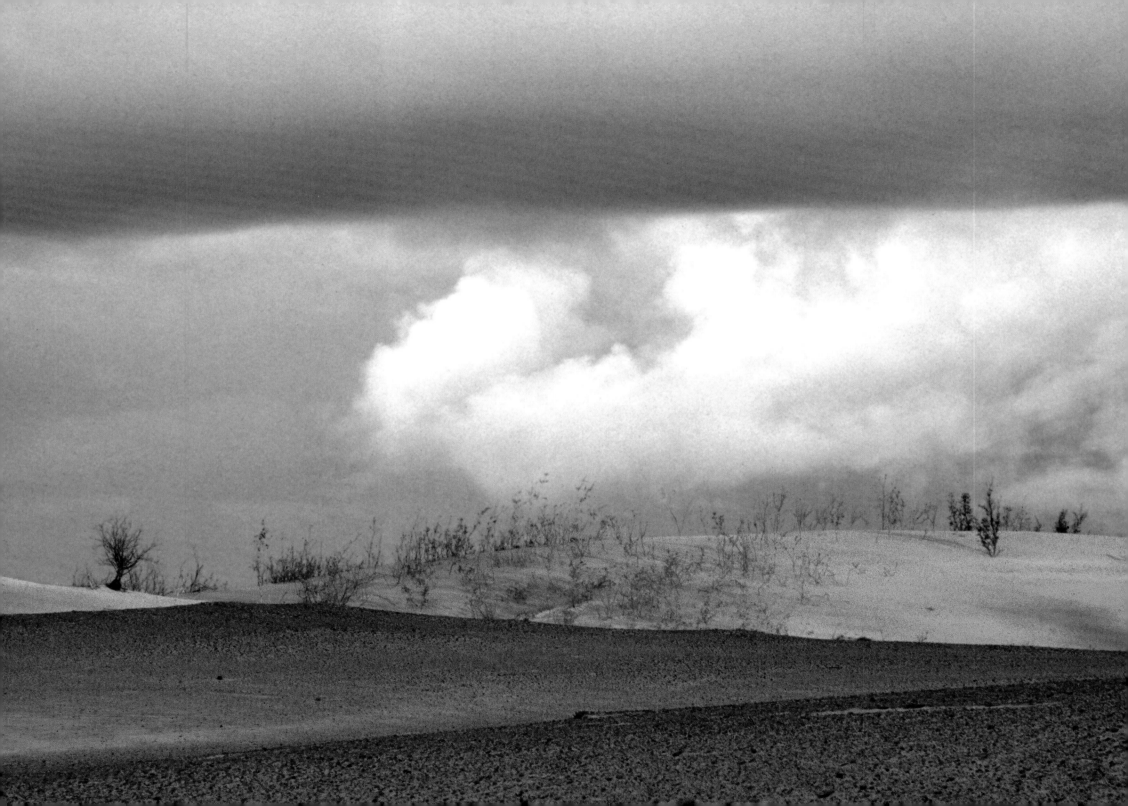

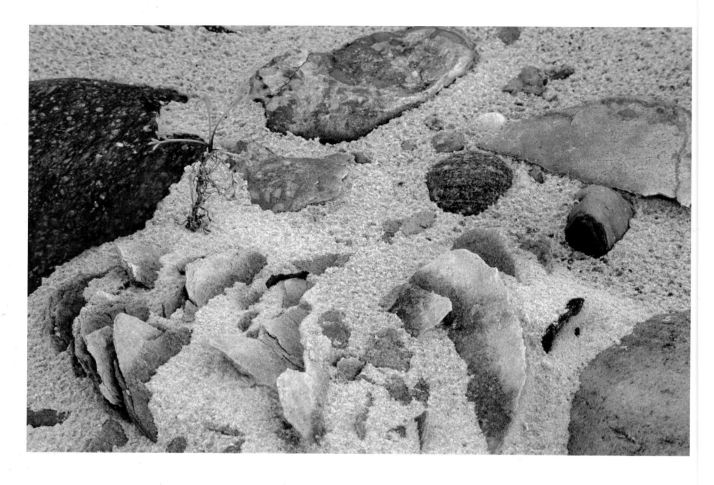

◀ On the edge of the dunes are deposits of rocks, often cut into colourful slices by millennia of extreme heating and cooling. To me, they are nature's rock gardens, inviting a leisurely stroll, especially in the soft glow of post-sunset light.

▶ The William River flows north through many kilometres of dunes, carrying with it millions of tonnes of sand. From the air, the river and dunes are like Saskatchewan's Land of Oz. The abstract patterns beneath the water's surface stagger the imagination while the scale of the artwork, more than half a kilometre across, pushes the limits of credulity.

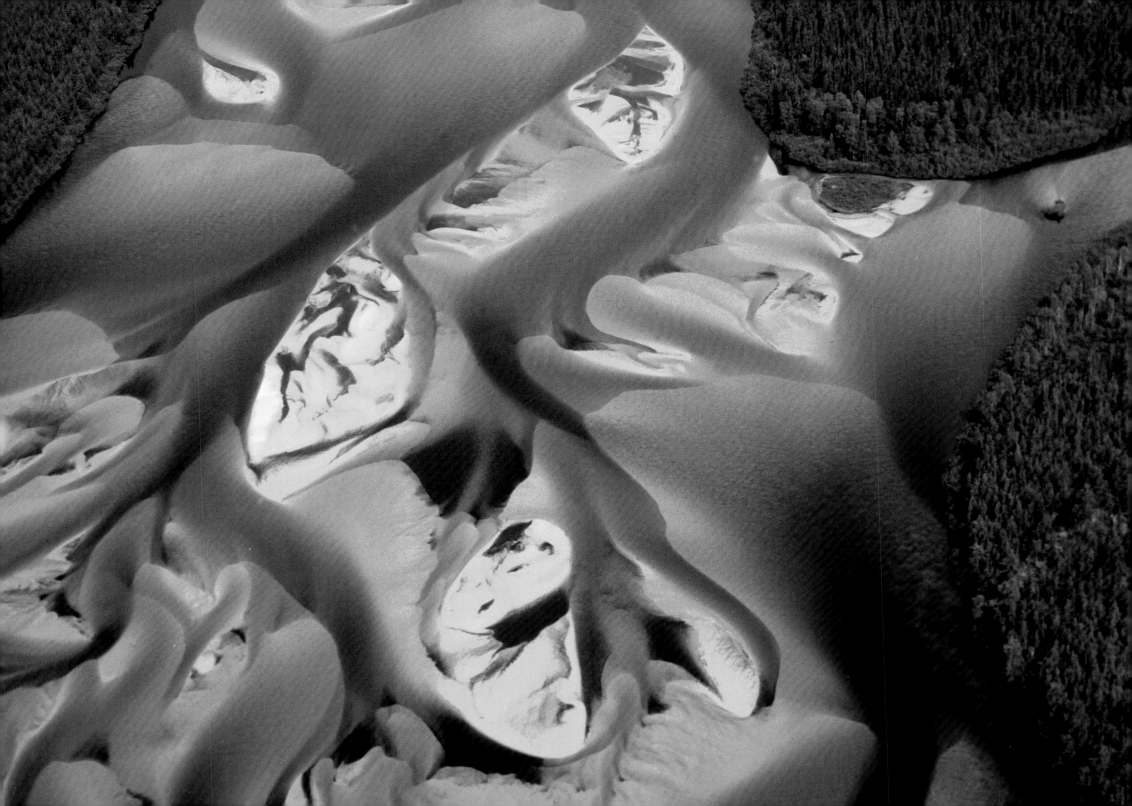

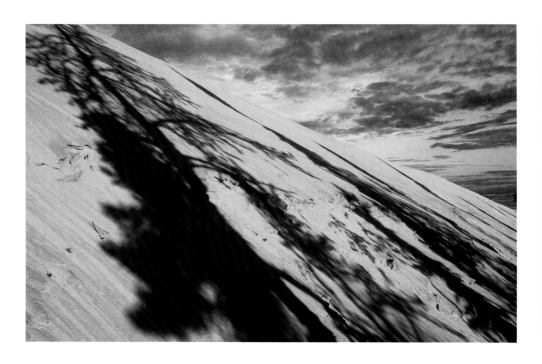

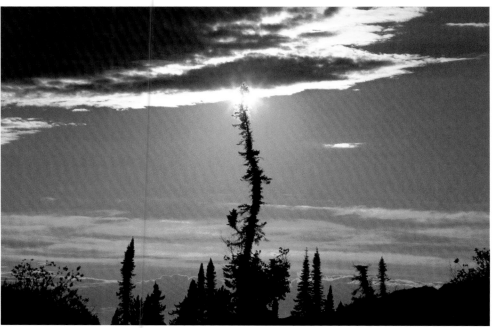

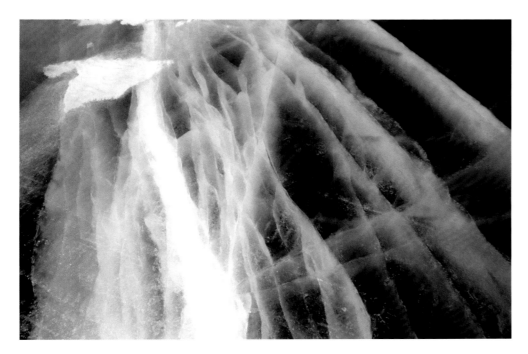

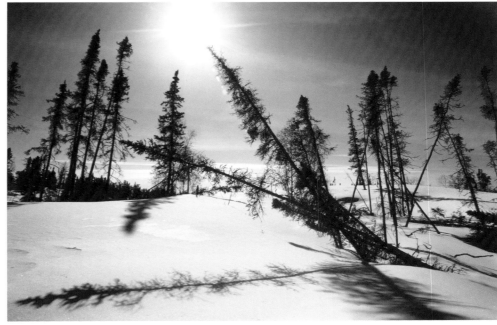

Every winter, when Lake Athabasca freezes over, the ice swells, causing enormous fissures to form. Towards spring, as the surface becomes windswept, these cracks become exposed.

One fine day, late in May, loaded with camera, tripod and lunch, I am delivered by sleigh to a remote spot on the lake with the fervent promise that I will be picked up six hours later. I spend a glorious morning recording the graphic patterns in the ice until the noonday sun melts the surface, soaking my feet in my not-so-waterproof moccasins, in spite of my attempt to stand in a garbage bag that I had bought to protect my camera from blowing snow. It is a long wait for my pickup that day!

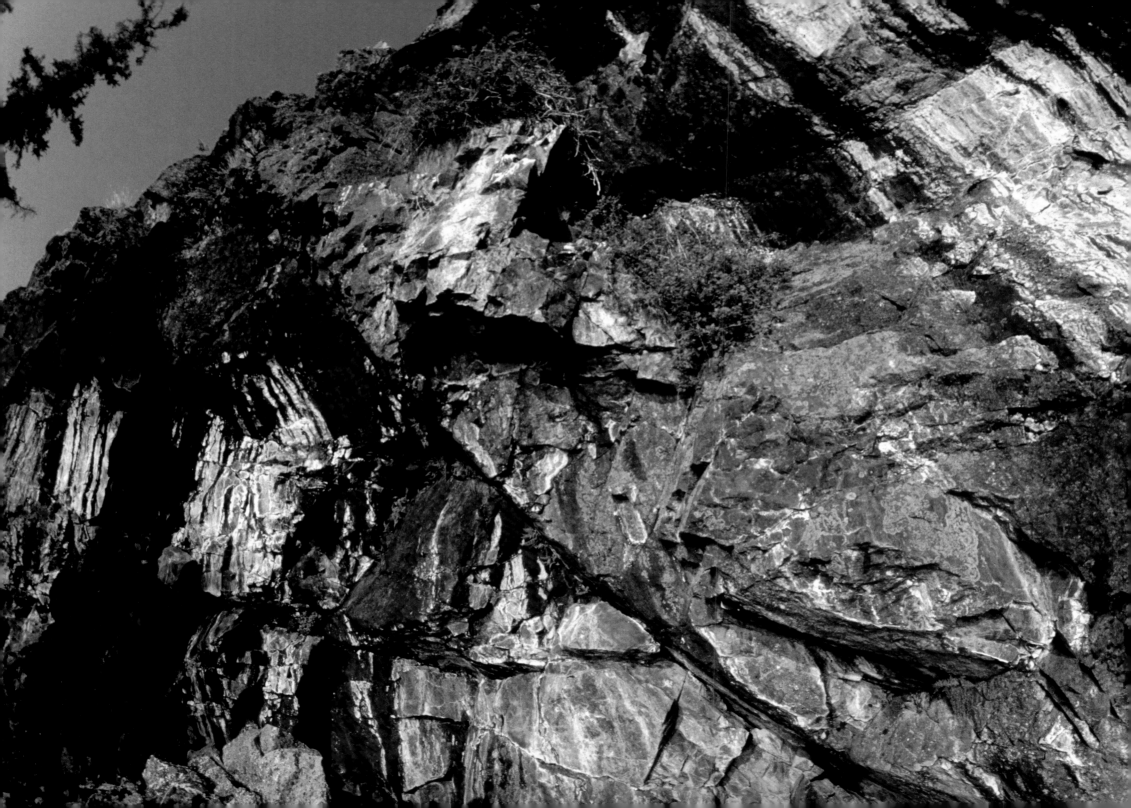

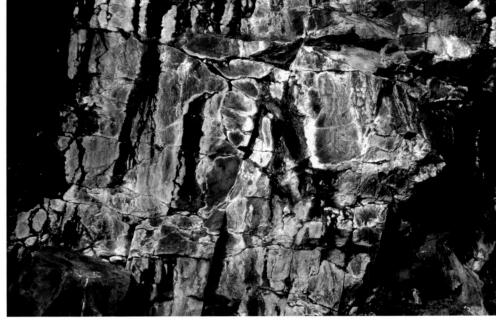

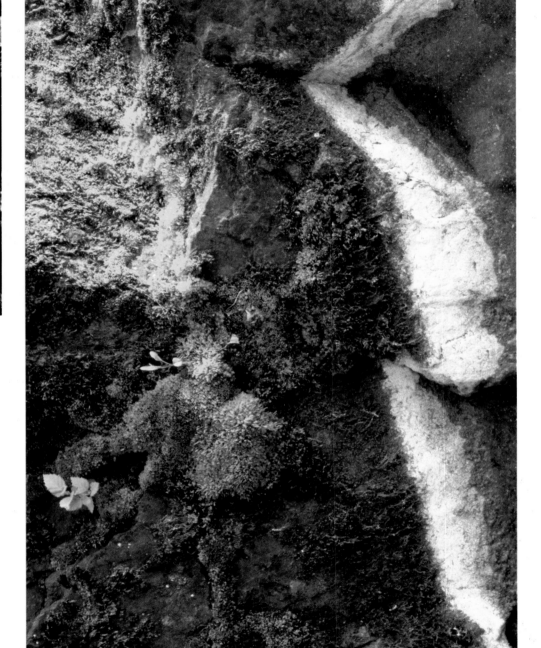

On the west rim of the Crackingstone Peninsula, an enormous cliff harbours one of Lake Athabasca's most prized possessions, a place I call the amphitheatre.

▸ A shard of light on a shady motif contributes to the rhythm of this evening sonata.

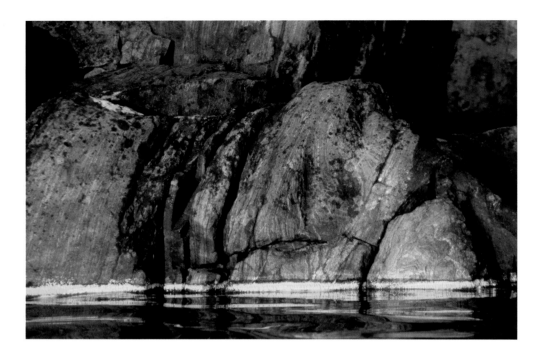

On a boat trip through the islands of the Crackingstone Peninsula, I am intrigued by a yellow band on the shoreline rocks. Locals identify it as pollen released from male coniferous trees. Since it is a late spring, the volume is more pronounced than usual.

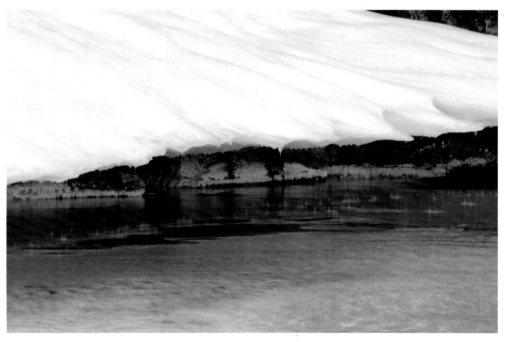

Even though the July temperatures are desert-hot, this mini-glacier hidden by shade in the midday heat has survived, revealing its pollen petticoat in the rich evening light.

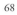 Rock turns to fire and lake swallows sky—all the elements of the I-Ching unite on this lakeshore of the enchanted North.

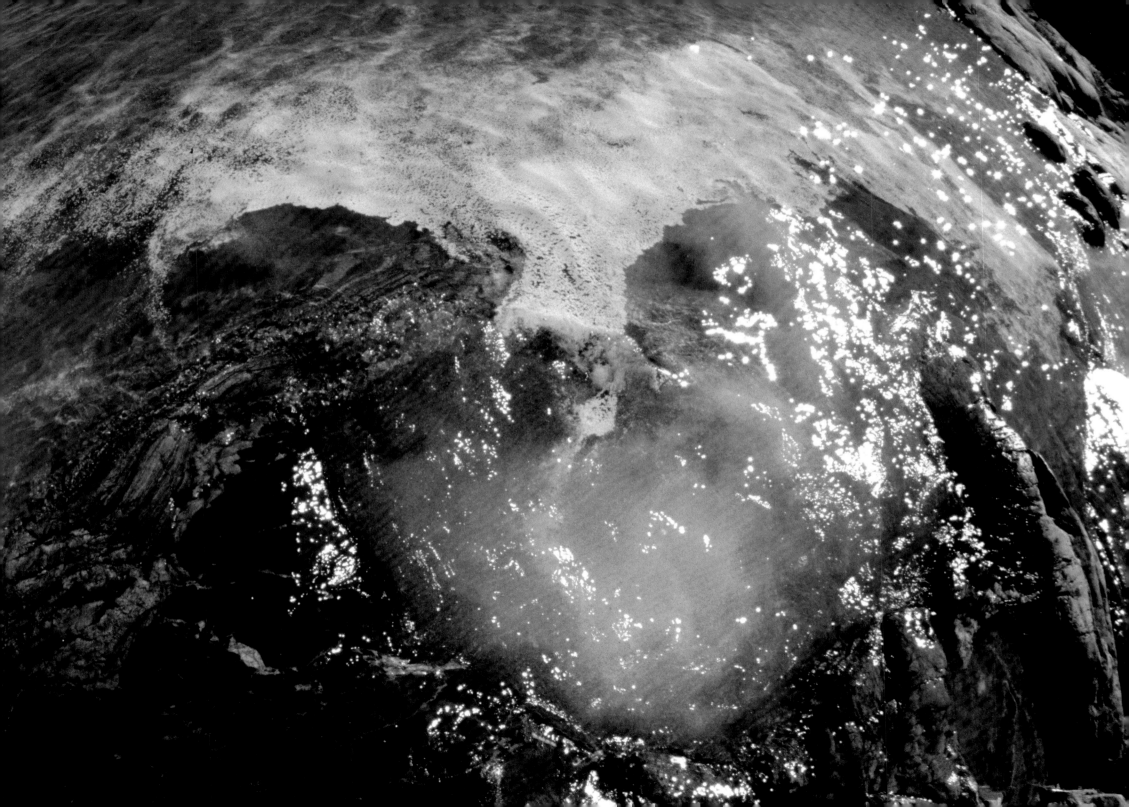

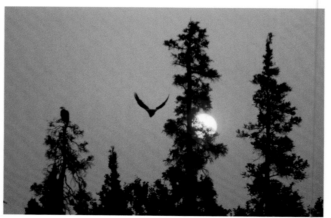
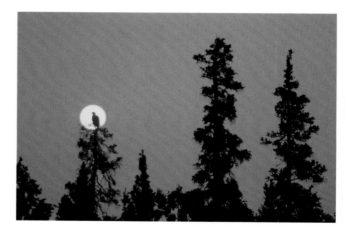

To an eagle or an angler, detecting subtle movement in the water can make the difference between catching dinner or going hungry. Watching a pair of nesting eagles is one of those special moments reserved to the North, but photographing them against the muted sun is a magical experience.

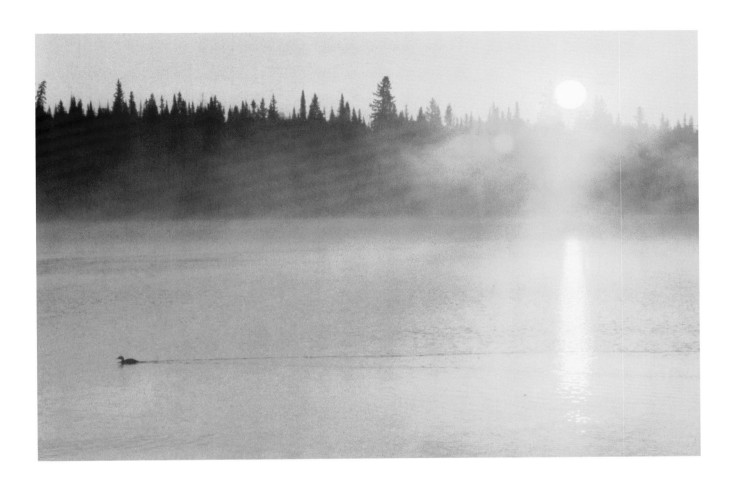

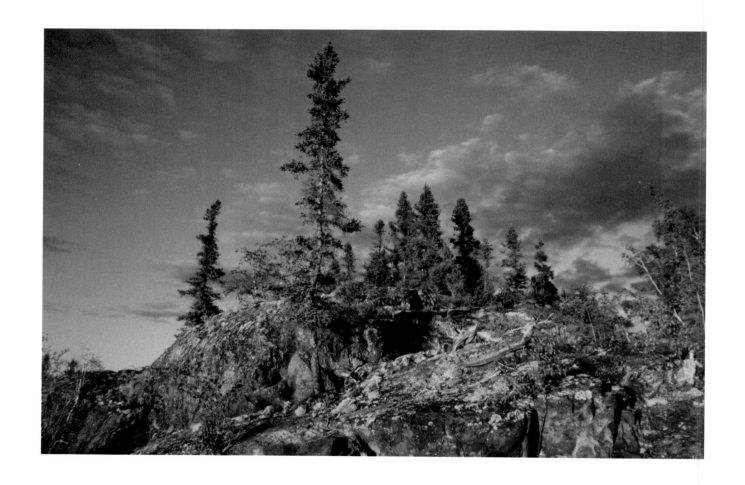

In mid-July, the thermometre soars to oven temperatures, and mosquito nets become an essential part of the wardrobe. Cool evenings thus become a favourite time for exploring and photographing.

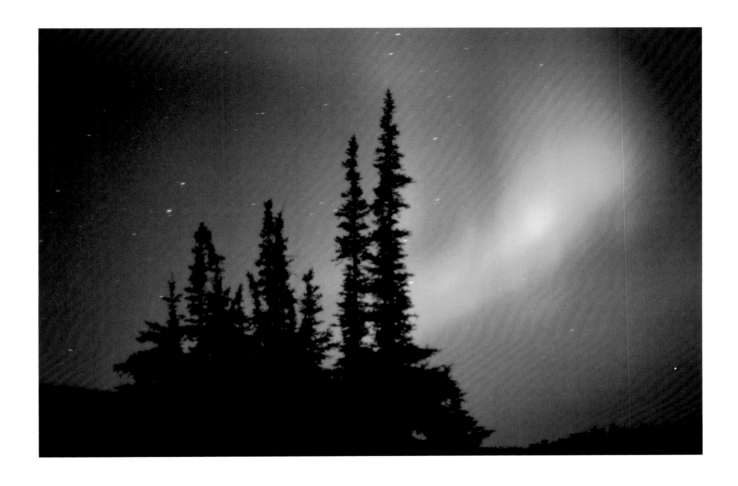

Then, as the sun slips into the lake and all but the northern rim of sky fades into darkness, the dance of the lights begins. With the stealth of a cougar—they stalk us in silence, then leap from an unseen celestial perch to dazzle us with their prowess.

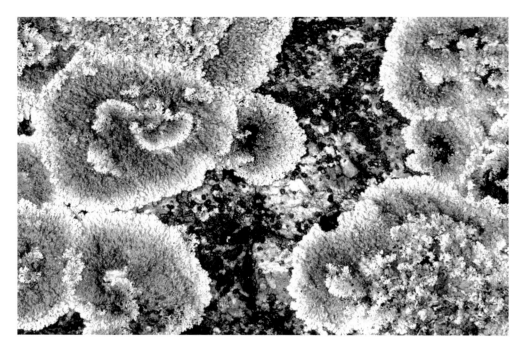

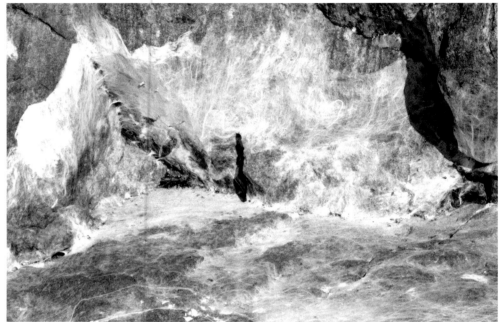

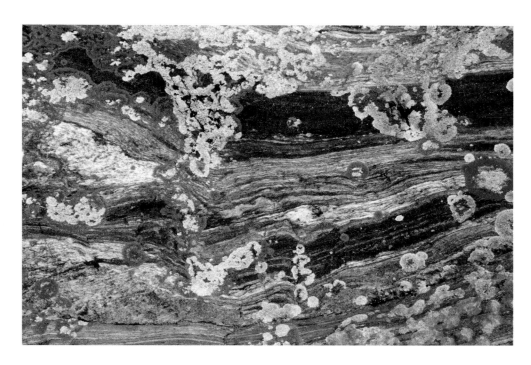 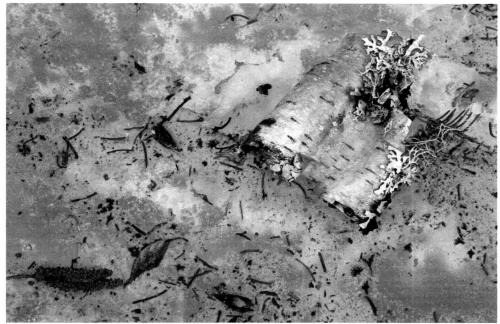

What ancient wisdom guides the artistry found in ice and rock? For whose pleasure has nature arranged these striking miniature exhibitions? Perhaps nature's ultimate purpose is to provoke us to tune our senses to what is beyond simple identification and to teach us how to master the art of awe.

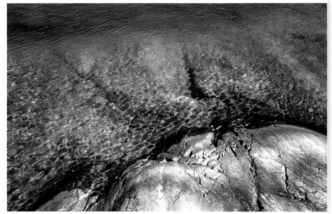

Peering through the viewfinder is an effective way of isolating a small piece of nature from the rest of the world. The resulting image often expresses a reality that our habits of seeing rarely allow us to encounter. Perhaps art's ultimate purpose is to restore in us the capacity to see whole the force of nature acting in a single moment. An artist then becomes a tour guide to landscapes previously unseen, perhaps to unveil glimpses of the restless energy that fuels all living things.

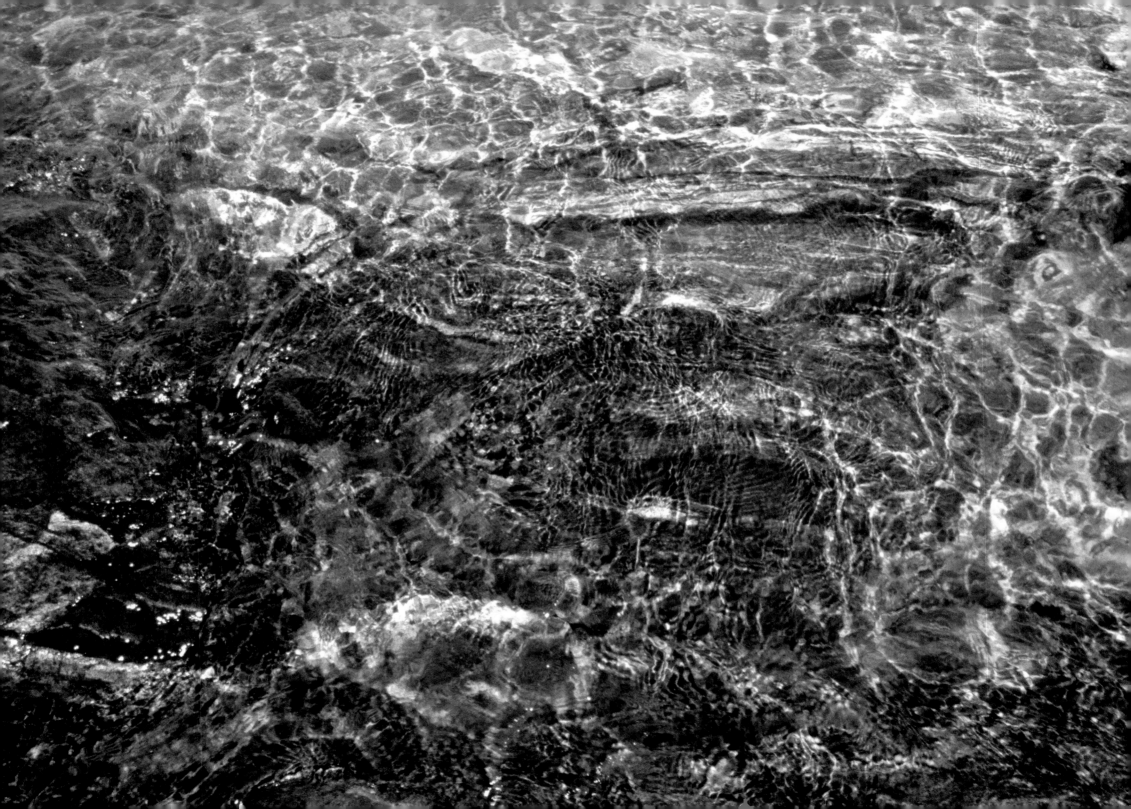

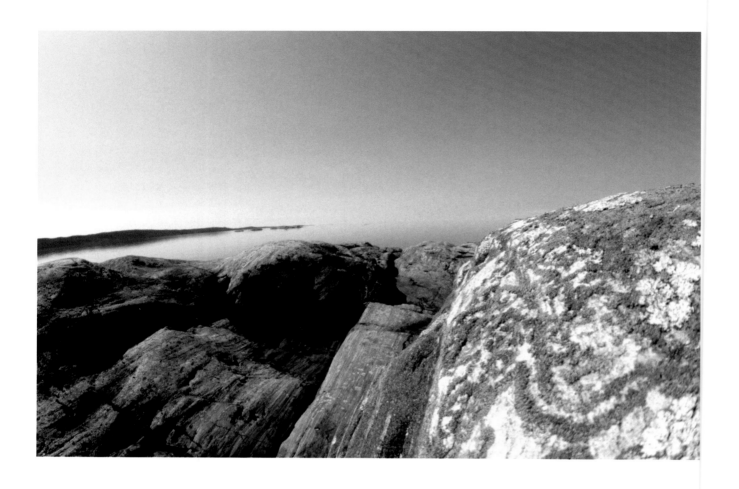

THE GREAT SOUTHWEST
a journey into time

Saskatchewan's southwest, with its ancient history of dinosaurs, is indeed a journey into time. For me personally, photographing there is always a journey into time because I have been photographing there for more than thirty years. My chockfull scrapbook of my favourite shoots includes the Frenchman River Valley, the Cypress Hills, the Great Sandhills, and Old Man on His Back Nature and Conservation Area.

The opportunity to teach photography each June at Cypress Summer, the arts program of the Swift Current Arts Council at Camp Shagabec, first drew me to the Cypress Hills and began a love affair to last a lifetime. Field trips with twenty shutterbugs in tow included the Conglomerate Cliffs, Bald Butte, "the bog" and a sea of wildflowers on the trail to the West Block.

Before long, I met Dan Rayner, who knew the backcountry and guided me to viewpoints not accessible by road. He later conducted a three-day trip by horseback from a ranch near Cabri westward across the Great Sandhills to what was then the Yeast Ranch. Despite my saddle sores and bruised ego from being thrown from my horse, the adventure opened my eyes to the primal beauty of this wild land. On the last day, the big dunes, bare of vegetation, came into view.

Dan introduced me to Frank Yeast, whose father had settled here from Nebraska. "Did you see them wild ponies?" he asked in a decidedly southern drawl. "A white one and a gray. Never been touched by human hands. Saw 'em yesterday out by the south windmill." He immediately had my full attention. "Let's go get 'em."

As we drove out in search of the wild horses, Frank told me how they were the offspring of a herd that escaped years ago. Soon my hands were shaking as I braced my 500mm lens against the truck window as I shot frame after frame. Suddenly, they galloped away, so we jumped back in the truck, catching sight of them again twenty minutes later. Just as I was getting out of the truck, they reared as if dancing for my camera. Time for one shot only before they vanished again.

Since that day, I have camped alone in the Southwest, sometimes for a week at a time. At night, I often hear the sounds of that herd of wild horses whinnying and pawing the ground near my camp, but I have never seen these phantoms of the hills again.

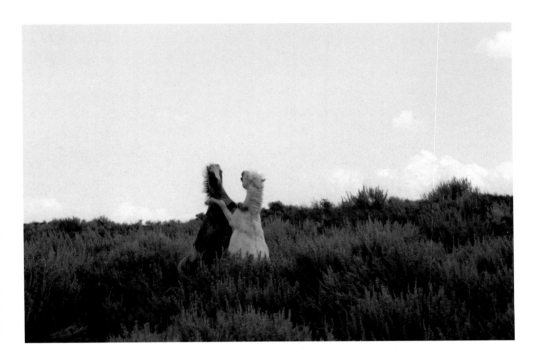

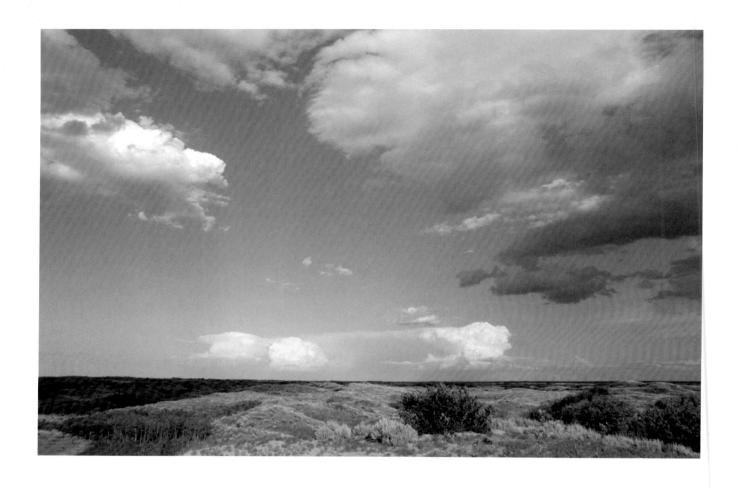

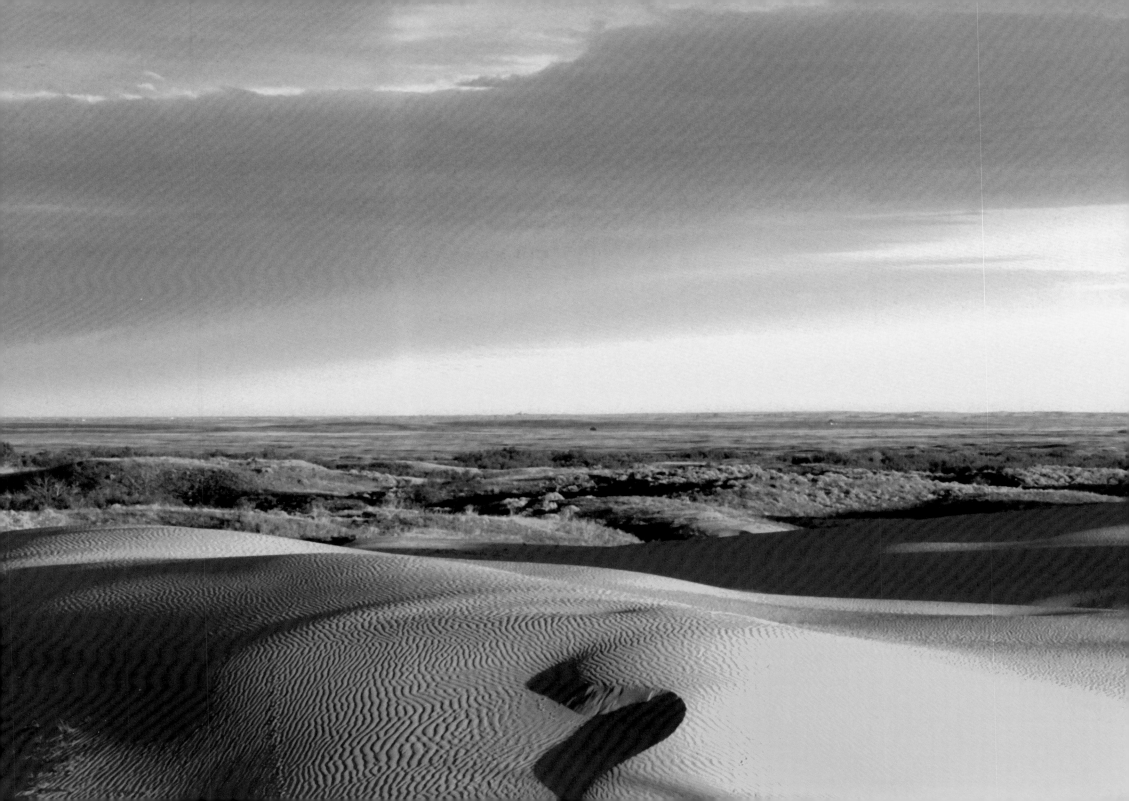

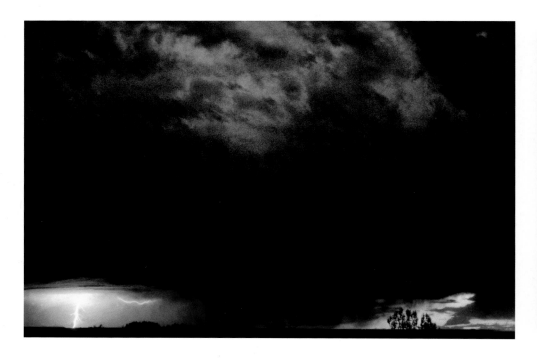

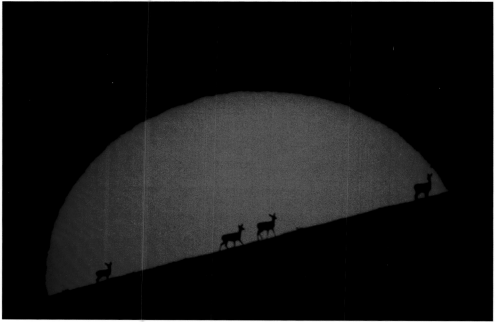

My favourite times to wander the sandhills are at the margins of the day. Hot summer days can remain cloudless until the late afternoon and then become filled with raging thunderstorms by nightfall.

Dawn is an excellent time to spot deer on the move, especially when they are silhouetted on a ridge.

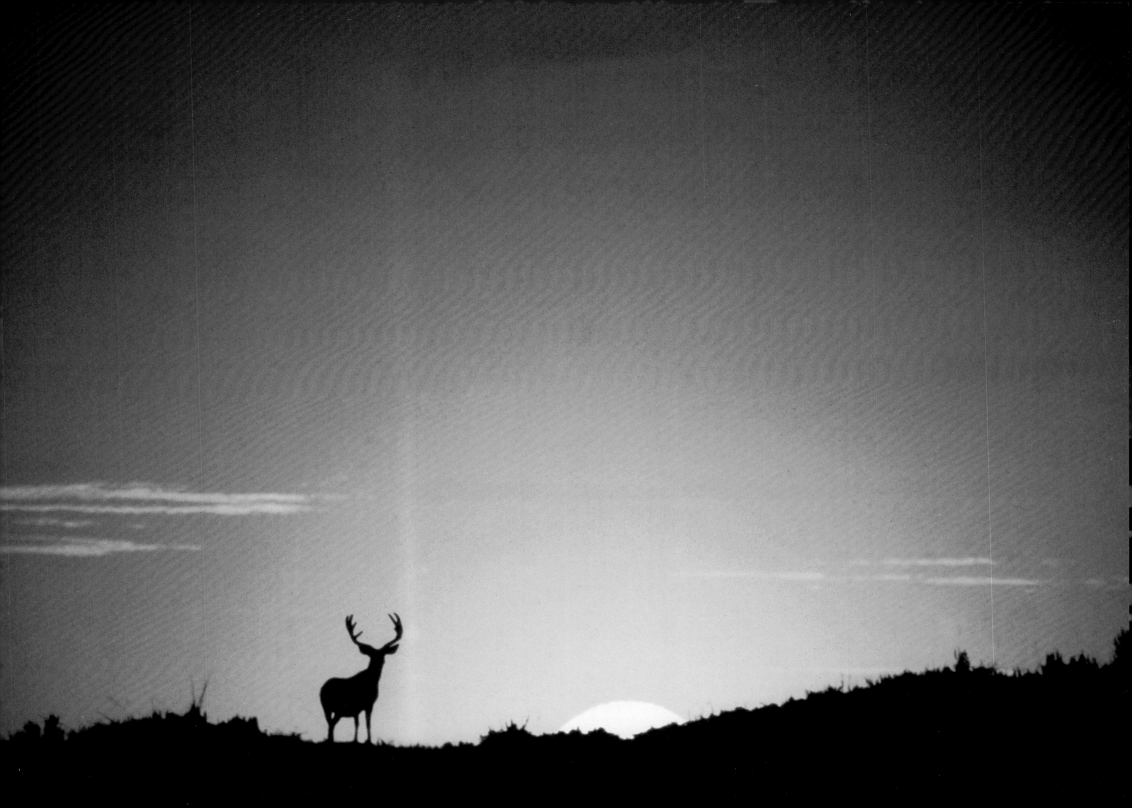

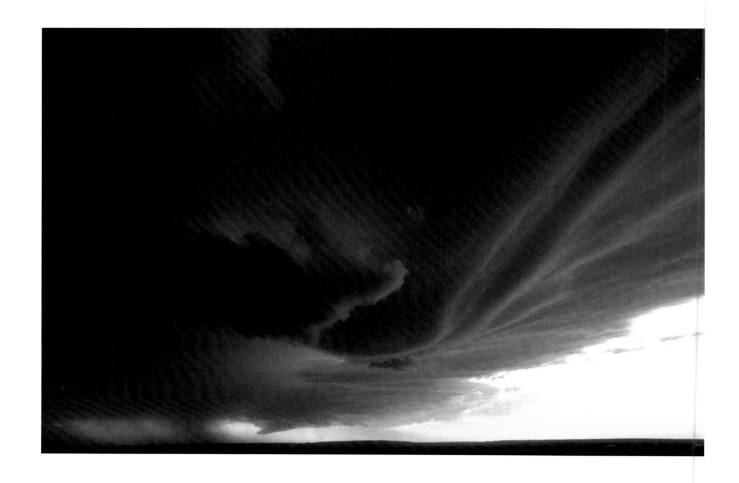

In recent years, I have taught photography workshops at Spring Valley Guest Ranch north of Ravenscrag. The teaching involves many group outings during which I confirm exposure settings as we all line up with our cameras on tripods to photograph the moving panoramas that thunderclouds bring.

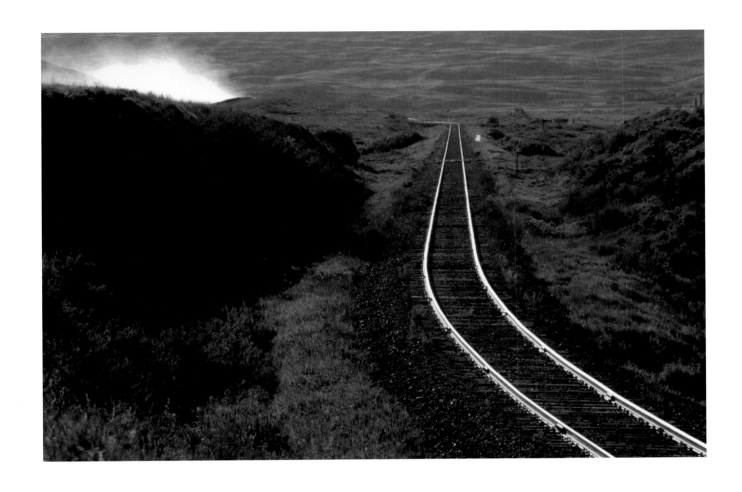

The Frenchman River Valley west of Eastend proves an ideal
location for exploring late-day light on railway tracks snaking
their way through the landscape—a dramatic contrast between
the natural and man-made.

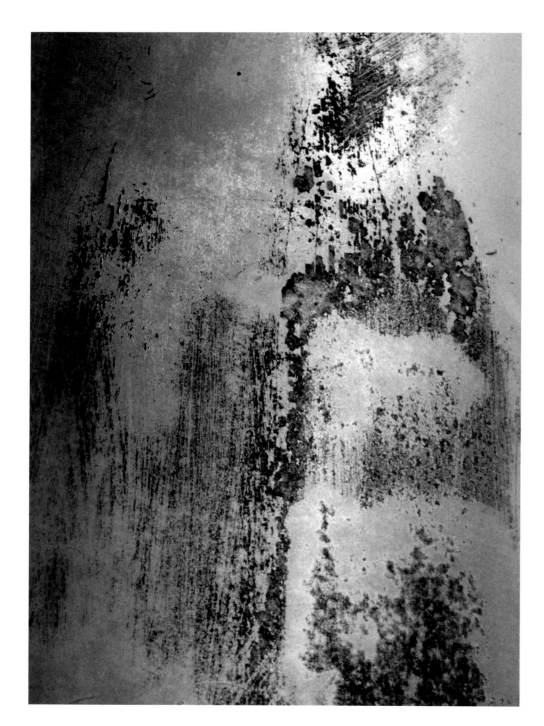

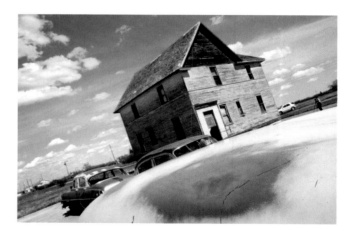

Though only a few families still live in Robsart, the town is a mecca of photographic possibilities. Observed closely, the weather worn buildings and numerous abandoned vehicles become painterly, offering an opportunity for fine-tuning one's eye for the abstract.

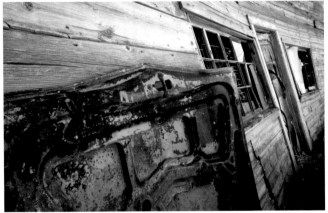

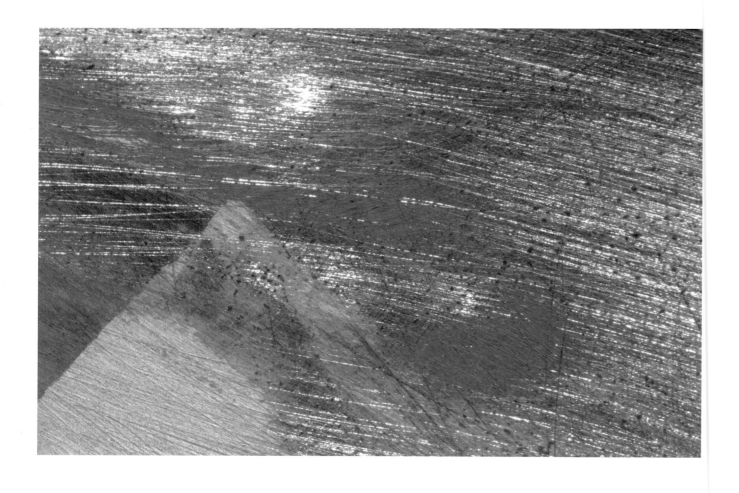

88

Having been mesmerized by the pyramids of Egypt, I never pass up an opportunity to photograph this classic shape, whether it be discovered in granary roofs with a pyramid of light breaking over them or in a rusty car fender at the Robsart "outdoor museum."

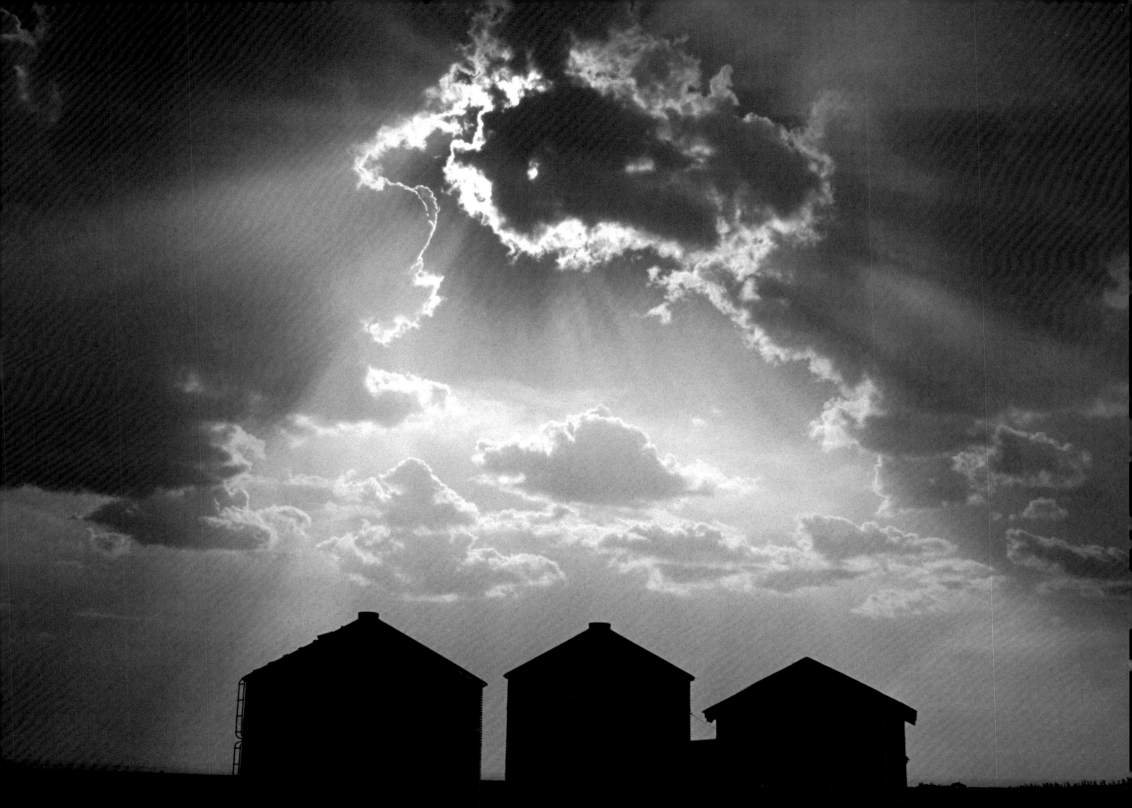

In the yard of the Spring Valley Guest Ranch, I assign each member of my photography class a piece of equipment or antique to photograph in order to push the boundaries of their seeing. They in turn challenge me to take the piece left over: the mudguard on a 1947 McCormack tractor.

With my 80–200mm zoom lens and a couple of extension tubes, I focus on the metal rim of the fender and am astounded and then delighted by the universe of glowing colour that is revealed. I keep returning to record the many moods that changing light provides.

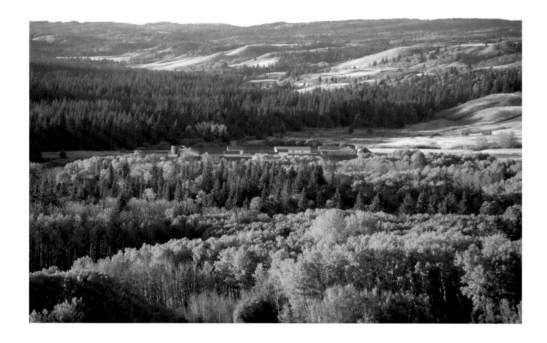

◀ A trip to the Cypress Hills Interprovincial Park is not complete without a visit to Fort Walsh. Both the refurbished interior and the surrounding pristine valley provide a glimpse of yesteryear and a reminder of our colourful history.

More than an hour's walk south of the fort is a group of large loaf-shaped boulders known as the Mystery Rocks. Almost at the summit of the highest elevation in Canada east of the Rocky Mountains, these rocks have long perplexed and fascinated visitors intrepid enough to make the climb.

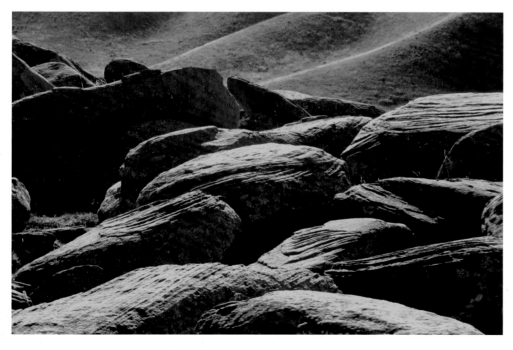

▶ The Grasslands National Park adjacent to the Montana border conjure memories of the Wild West. Spread over 906 square kilometres, this rugged, largely unfenced region is a combination of badlands and mixed grass prairie, and home to the prairie dog.

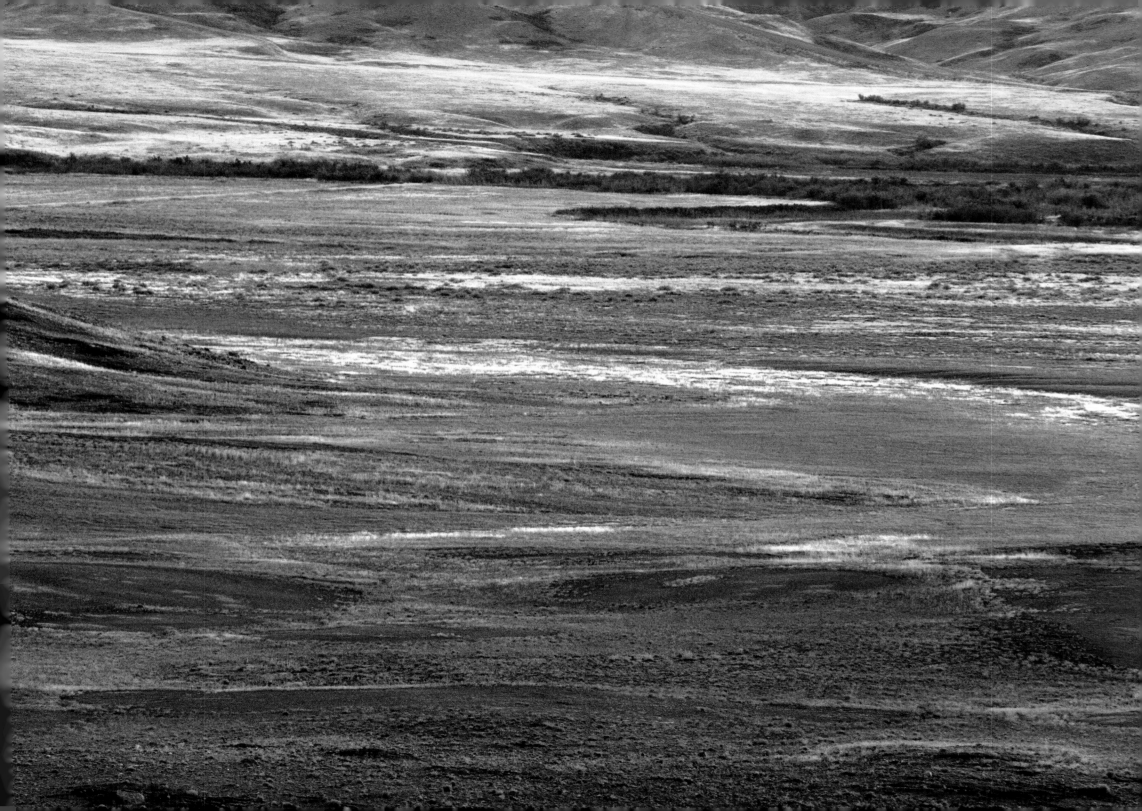

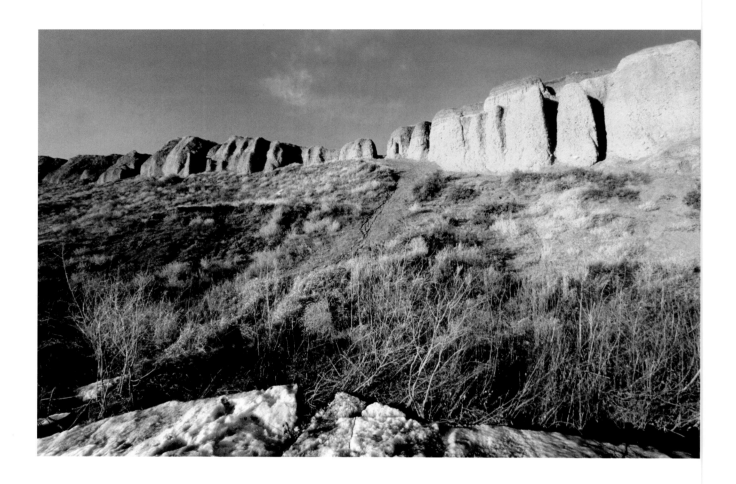

94

These cutbanks, among the highest in the Province, tower over the Swift Current River, called Speedy Creek by the locals. Though no bones or artifacts have ever found here, sheer drops like these made ideal buffalo jumps, where Cree or Lakota hunters, often on foot, stampeded the plains bison to their death. No part of an animal was wasted; even the bones were sculpted into implements.

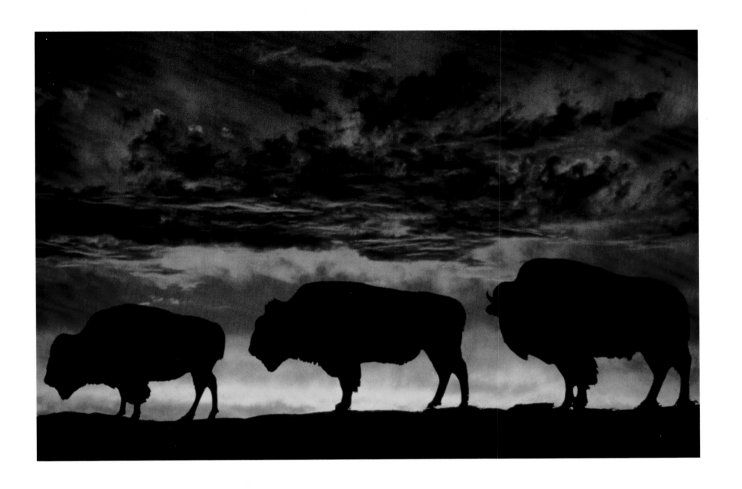

This image, which I have named Prophecy, is my tribute to the bison of North America. They are sacred to many First Nations people, whose spiritual tradition teaches to take only what is needed. Europeans, arriving in the West, shamelessly slaughtered them in the millions, driving them to the verge of extinction.

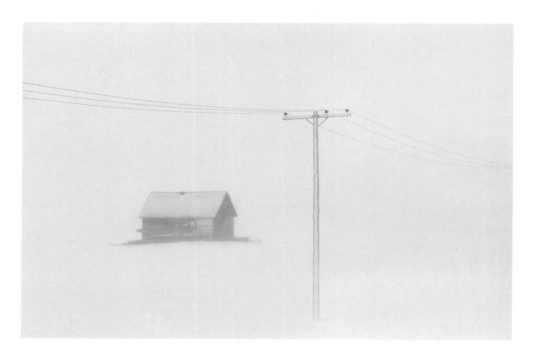

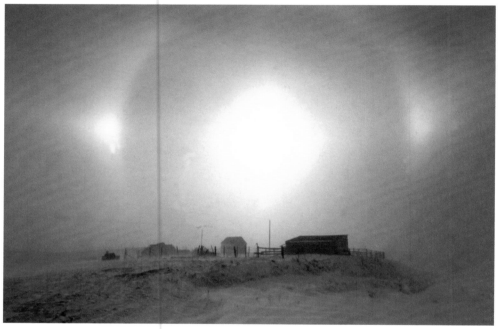

A soft but persistent snowfall blankets extraneous details and reduces the world to its essential elements. Without the power line and abandoned building, the scene would be completely featureless.

One thing that Fahrenheit and Celsius scales have in common is that both agree minus forty is cold! When the local radio warns motorists to stay inside, I jump in my car, head north of Swift Current and find this sundog near Stewart Valley. My cheeks are frozen by the time I return to the car. (My face is cold too!)

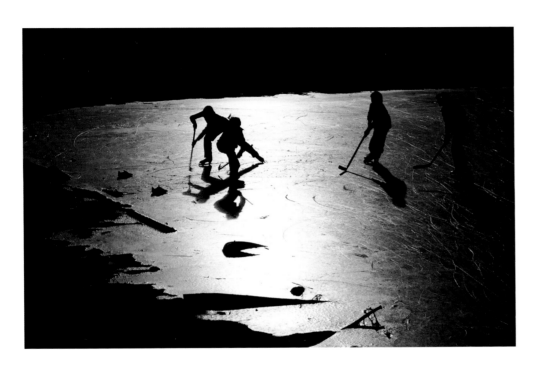

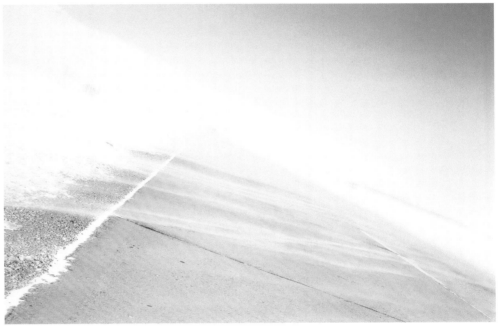

Our rural way of life has undergone significant change in the past decade, but it's impossible to imagine that hockey will ever completely vanish from the landscape.

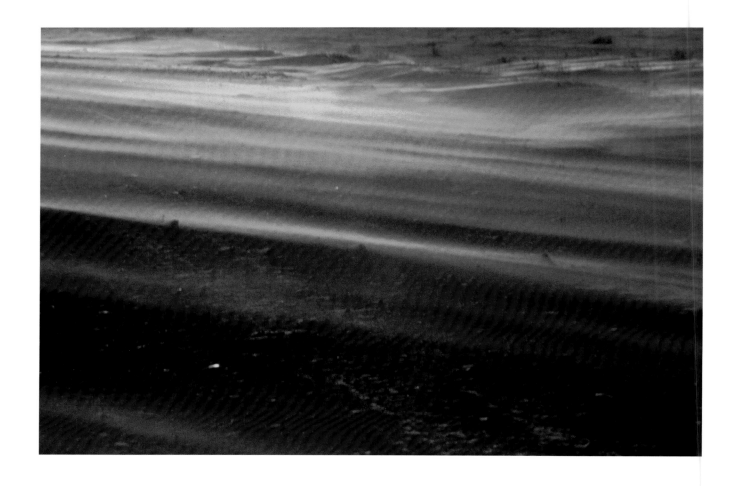

On a brutally cold day during my monthly visit to Old Man on His Back Prairie and Heritage Conservation Area, I find photographing this blowing snow at dawn to be one of my most challenging experiences.

YES! IN MY BACKYARD
familiarity breeds consent

We in Saskatchewan harbour a compelling sense of the home place and its connection to the land. We may wander the planet, we may move from farm to city, but when asked where home is, we know the answer. We are highly territorial beings, always remembering our connection to the land, and we take a great but quiet pride in what is—and always will be—home.

Whether we live in a rural setting or in the heart of our larger cities, we are still in close proximity to nature. The most urban home is only a short walk from a park or a few minutes drive from wide-open county. We are blessed with outrageous beauty above our heads and beneath our feet. This chapter is a reminder of what we have always known yet sometimes forget: We are never far from the beauty of the land if we accustom our eyes to seeing it in the world just outside our door every day of our lives.

Virtually every photograph in this chapter was taken within a short, leisurely walk from my house, and in most cases only a few steps from the door. Sometimes the intention to take just a quick shot or two leads to an extended photography session simply because luminous landscapes have a compelling power of seduction.

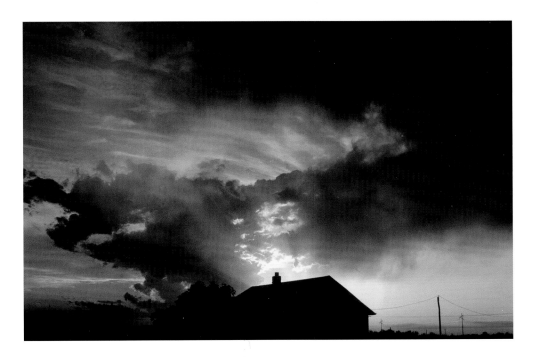

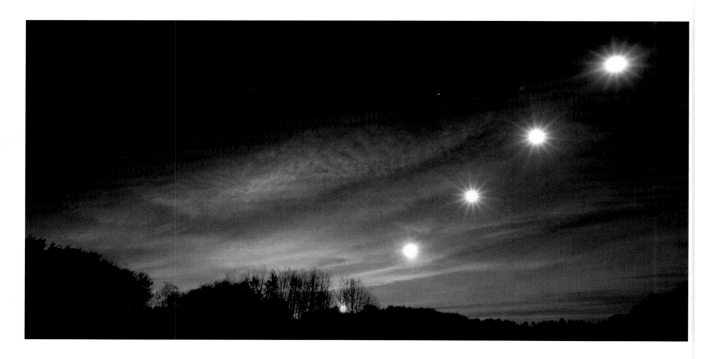

My east meadow becomes an ideal observatory from which to record the passage of the morning and evening sun during the autumn equinox, one exposure taken every forty-five minutes.

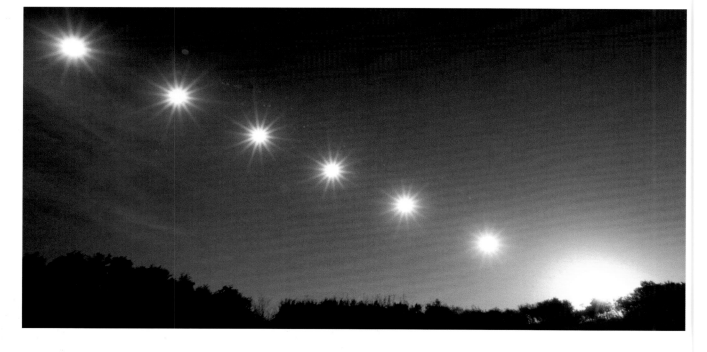

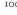 On the equinox, the sun sets directly at the end of our grid road. Through a 4,000 mm lens, it looks like a giant clam shell, the line of power poles dwarfed in comparison.

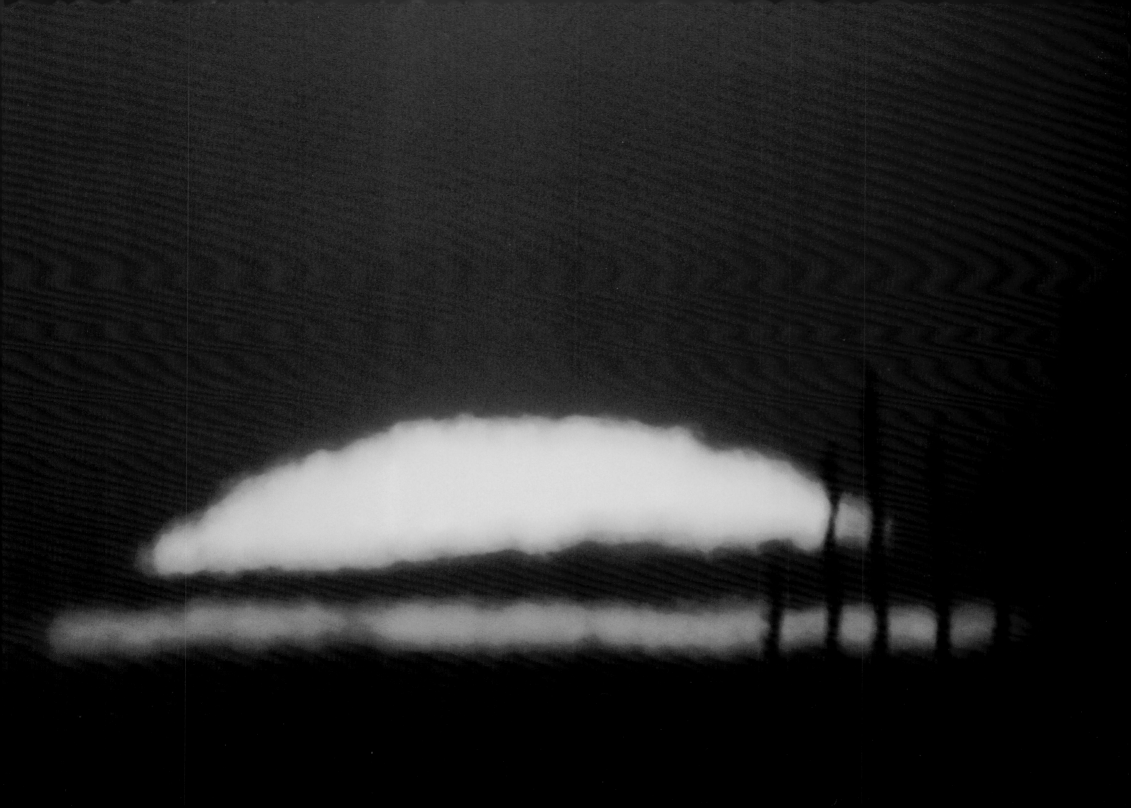

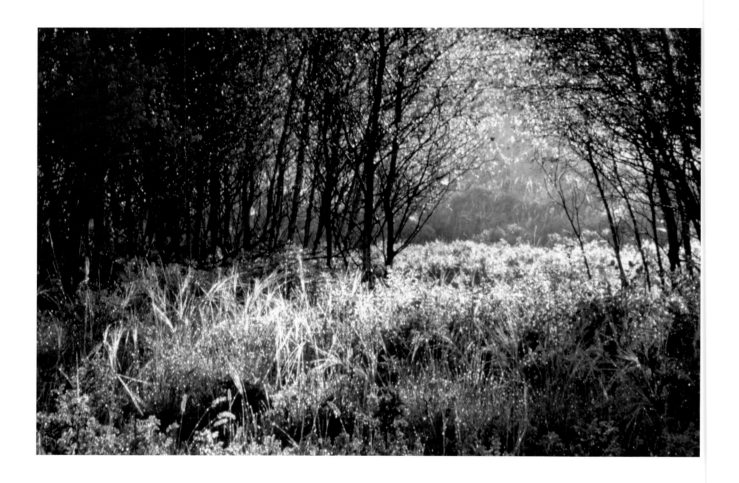

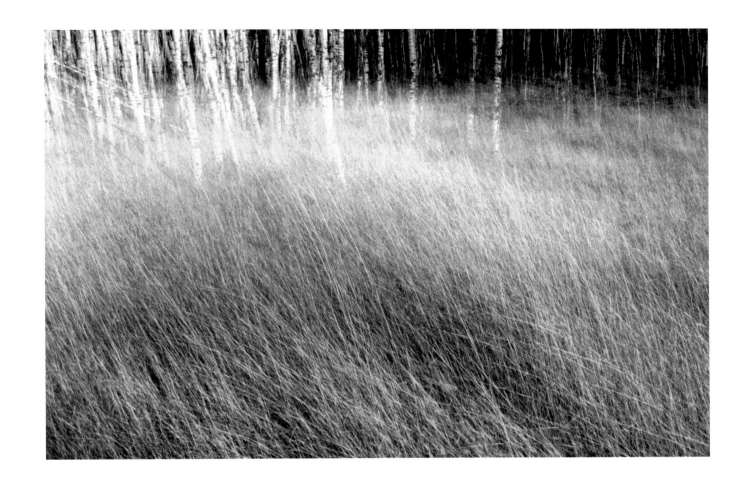

An early morning spent on paths around my home reaffirms my
connection with the natural world and encourages me to pause
and admire the beauty to be found in the otherwise mundane
and familiar.

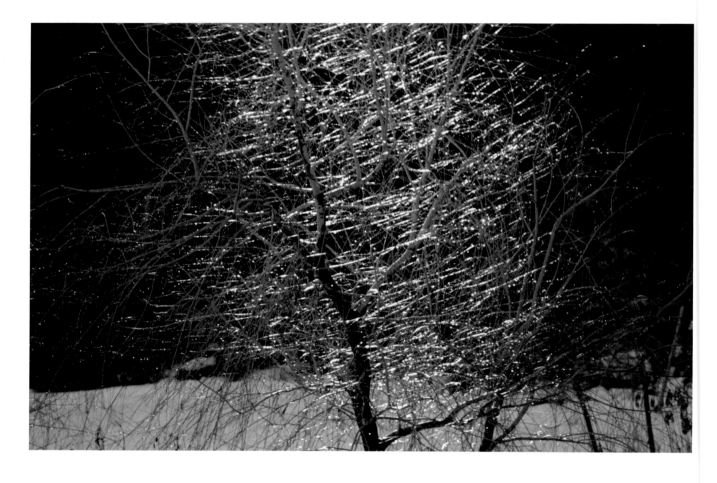

◀ In early April, the cherry tree in our front yard takes a direct hit from the morning sun.

104

▶ We who live on farms and acreages, away from city lights, know the majesty of inky black skies. I set my camera on a tripod to record time exposures of brighter stars tracing their arcing paths around Polaris. A dividend on viewing the image is discovering the various star colours, something not often noticed with the bare eye.

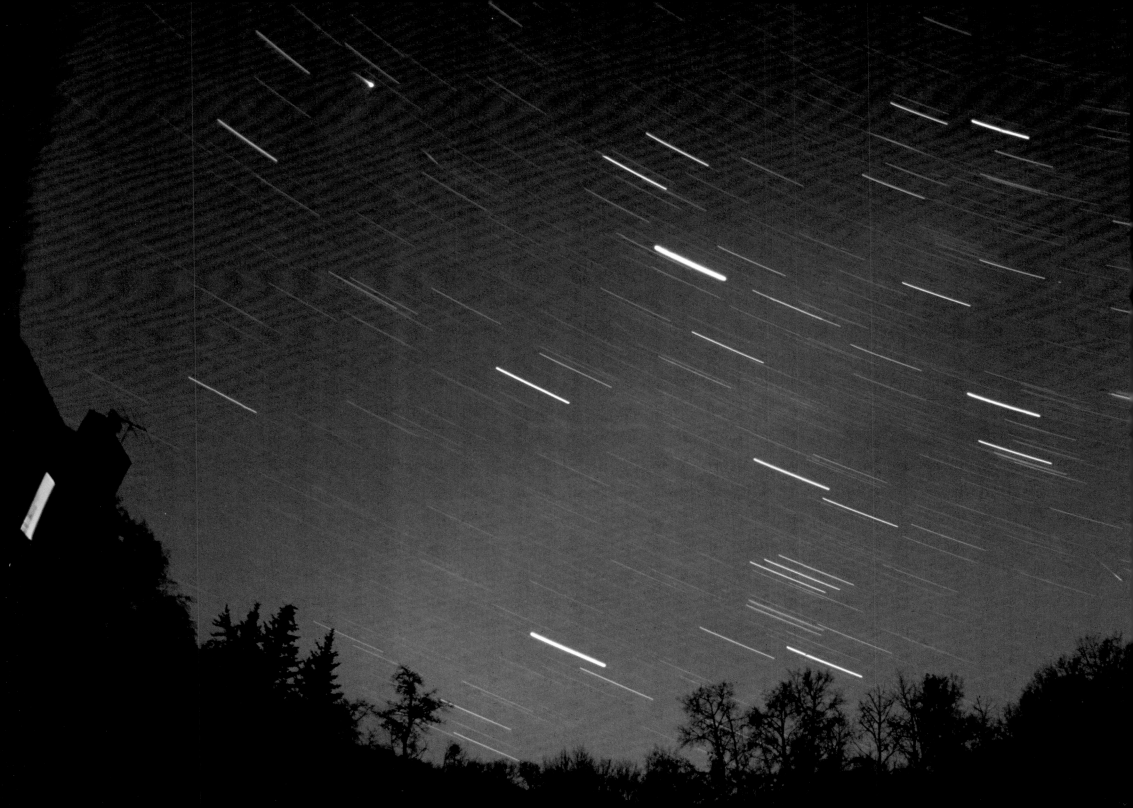

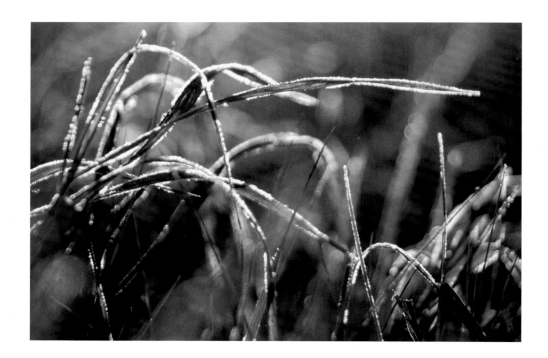

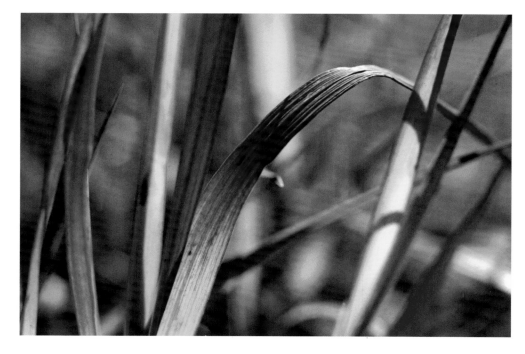

In *To Be Healed by the Earth,* Warren Grossman describes how, after being given no hope by his doctors, he was rejuvenated by lying on the ground everyday, regardless of the weather. In spite of the cold nipping at my nose, photographing an early frost at ground level feels like a profoundly healing exercise.

On this morning, I lie curled up with my macro lens in the ditch beside a busy road, my bicycle beside me. I look up to see people pouring out of several cars with blankets and first-aid gear. It takes some persuasion to assure them I am just fine and that I am lying in the ditch to record patterns of light on blades of autumn grass. I wonder if they leave wondering not about my physical health but my psychological well-being, and I wish I could persuade them to see the unexplored world just beneath their feet.

Because of our dry climate, we do not see morning dew as often as in the east or on the west coast. A zoom lens and one or two extension tubes are my preferred tools for viewing when the magic beckons.

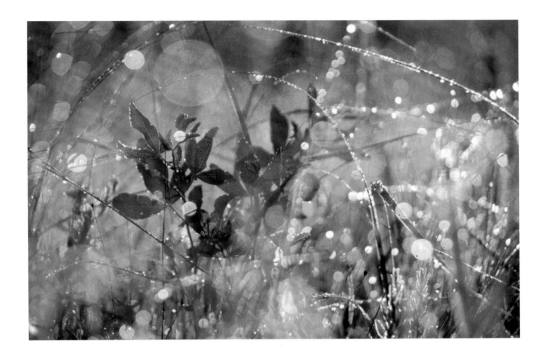

It's the Alberta license plates that read "Wild Rose Country," but I live smack dab in the middle of what must be ten thousand rose bushes. The roses, both seductive and enduring, attract insects that lure birds that lay eggs and hatch young, both of which are on the menu for a long list of other wildlife, an endless cycle of life spinning around the mainspring of the roses.

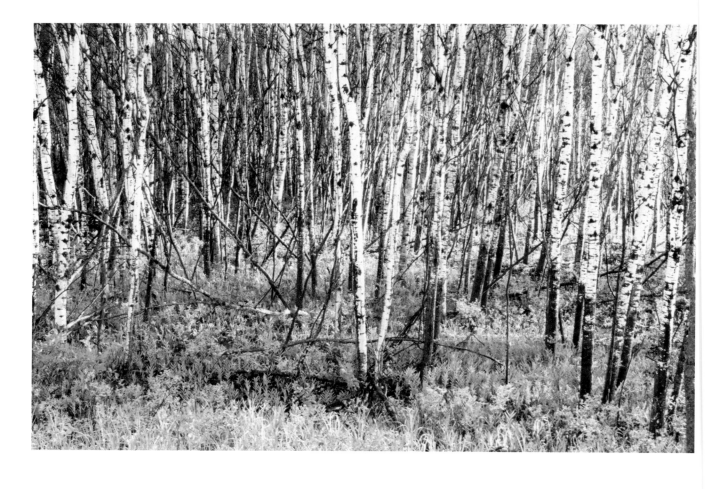

▶ Colour has always been a large part of my attraction to the land I call home. When I can't see the forest for the trees, I like to diminish their shapes by making several exposures, shifting the camera slightly each time and searching for the elusive majesty of light.

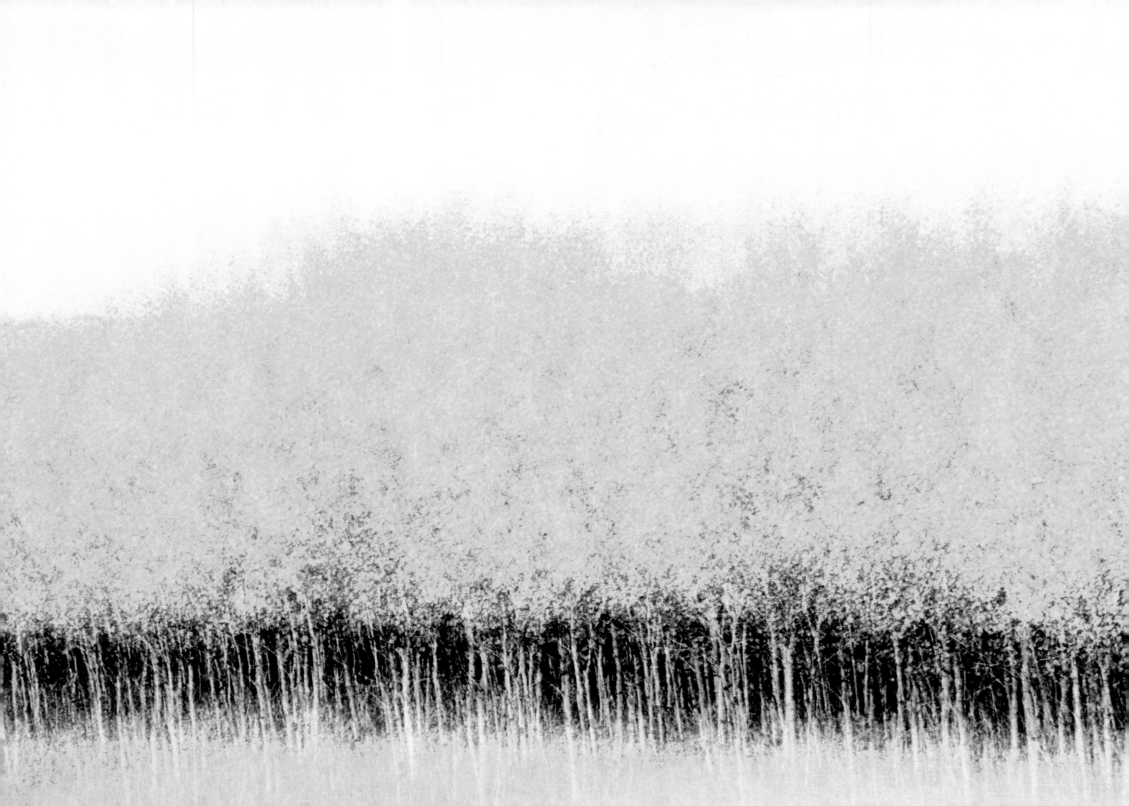

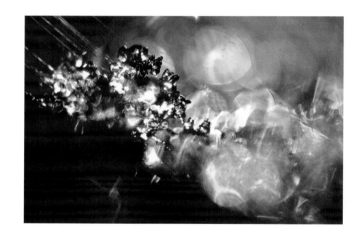
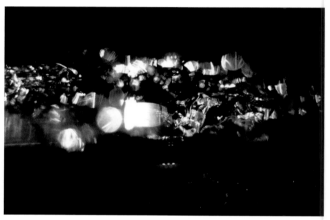
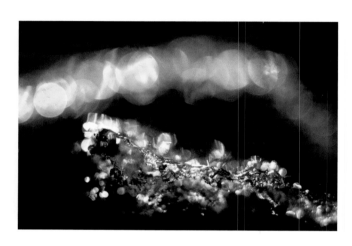

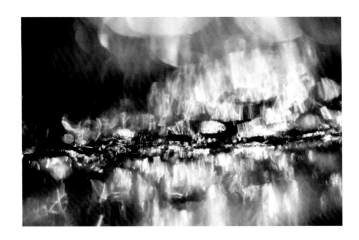 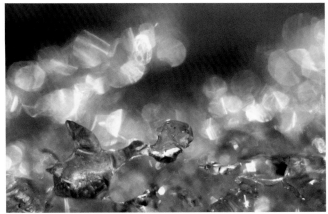 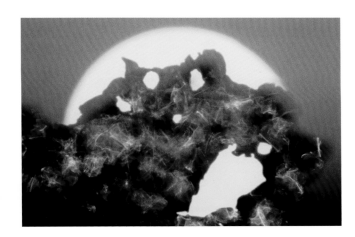

Each spring when the melting snowdrifts form crusts of ice, I love to spread out a plastic tarpaulin, drop down on my belly and escape into another world: The lost city of light rising from the melting snow. I pack a macro lens, several extension tubes and focus my attention directly into the light of the rising sun.

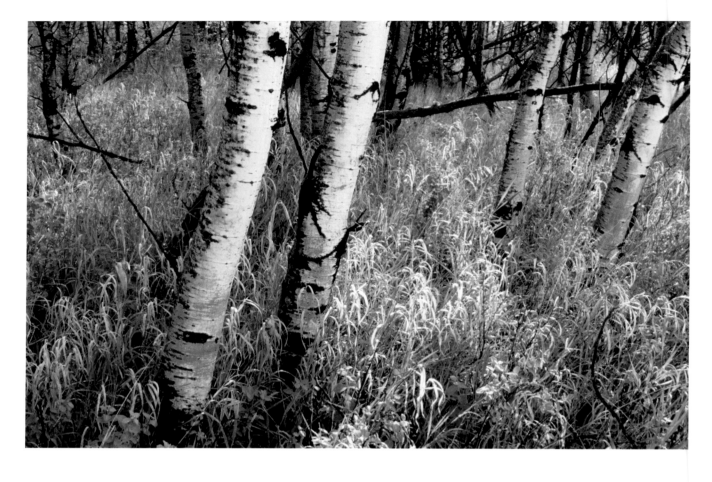

◄ I rise at 4:00 A.M. to capture the predawn light caressing the grasses in the grove.

▶ The first time I can remember seeing a magpie was in a park in Calgary. I was mesmerized by its shimmering colours and proclaimed that I had never seen such an exotic bird. "Oh," my friend laughed, "that's *just* a magpie."

But my first impression still resonates with me. On the underside of the tail feathers, I discover a rainbow of iridescent colours.

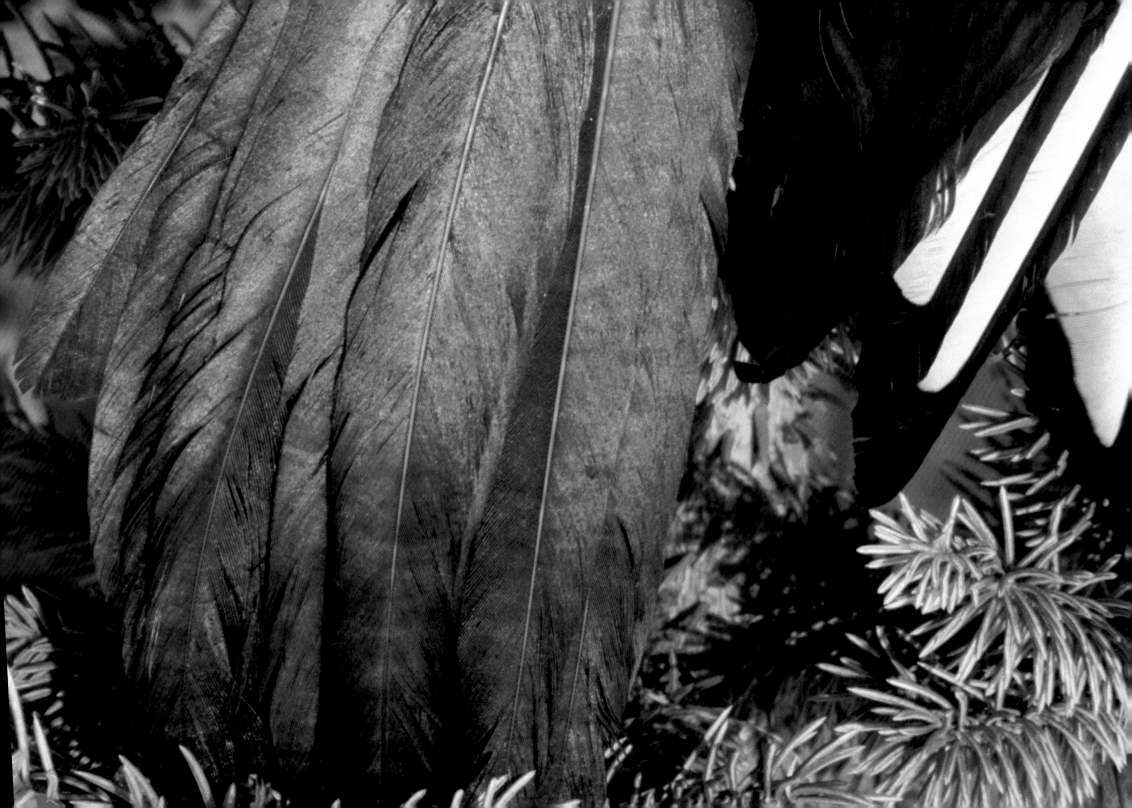

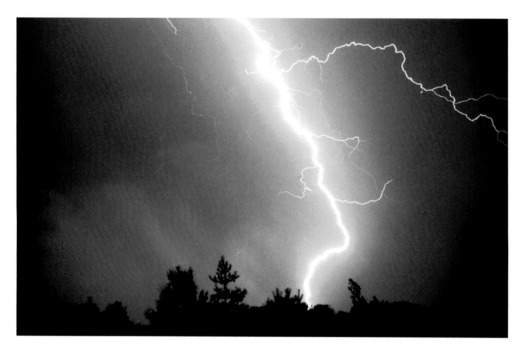

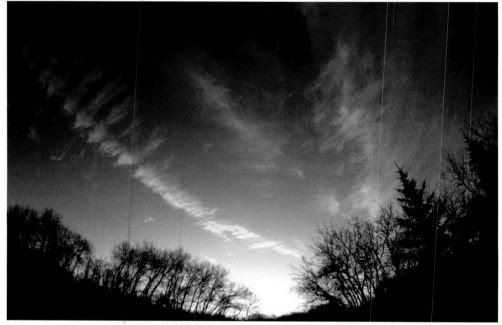

Summer is the best season to buy tickets to the Great Saskatchewan Electrical Storm. My price of admission was $5,000, the cost of burying the electrical lines. Now I can photograph lightning unimpeded from the safety of my garage.

Hanging in my hall window is a glass ball that takes on different moods depending on the time of day, the weather and the season. I never tire of peering into it with my macro lens to see what enchanting universe of light will unfold.

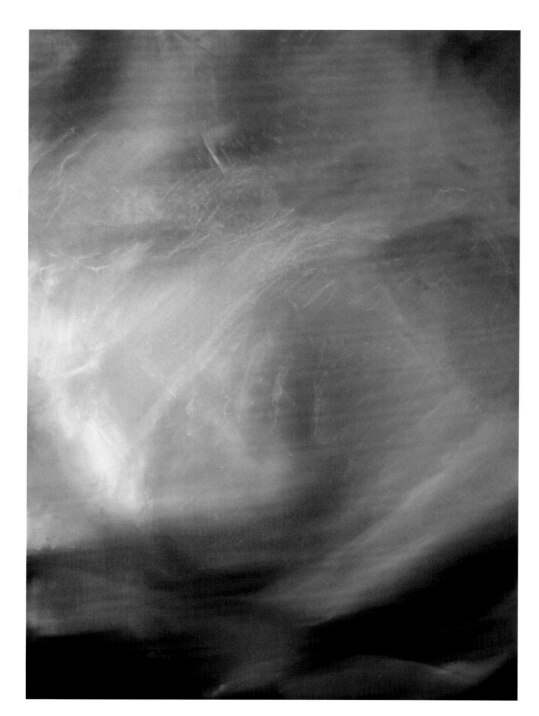

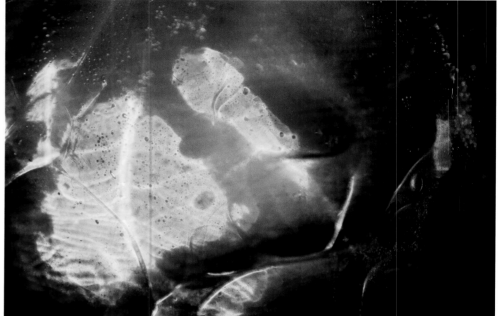

Whether admired in cool afternoon light or absorbing the golden rays of the setting sun, my "crystal ball" is teased by the magic of the southern sky.

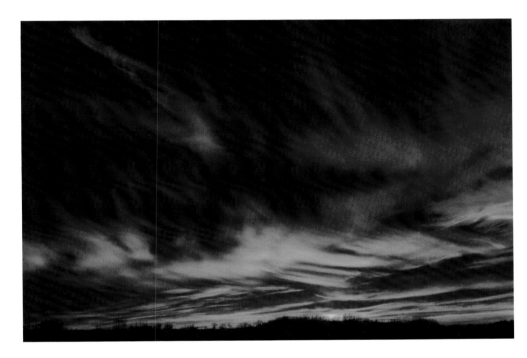

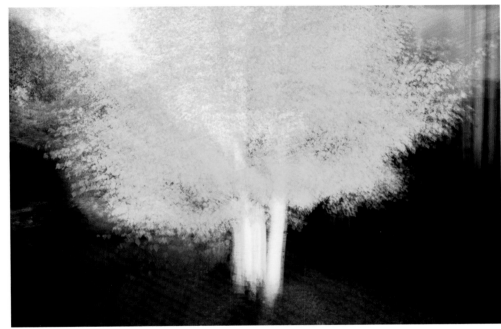

Driving home one August evening the sky suddenly catches on fire. I look around, desperately searching for a view that isn't full of poles, wires, trucks or hydro towers. I head for the first side-road off the highway, ditch the car and leap into the brightest of the flames.

The closest tree to the house in our front yard is a stately water birch. It is elegant in all the seasons but at its most glowing in autumn when backlit by the setting sun. To enhance the feeling of its vibrational quality, I make seven or eight exposures of it on the same frame, with slight shifts of the camera for each exposure.

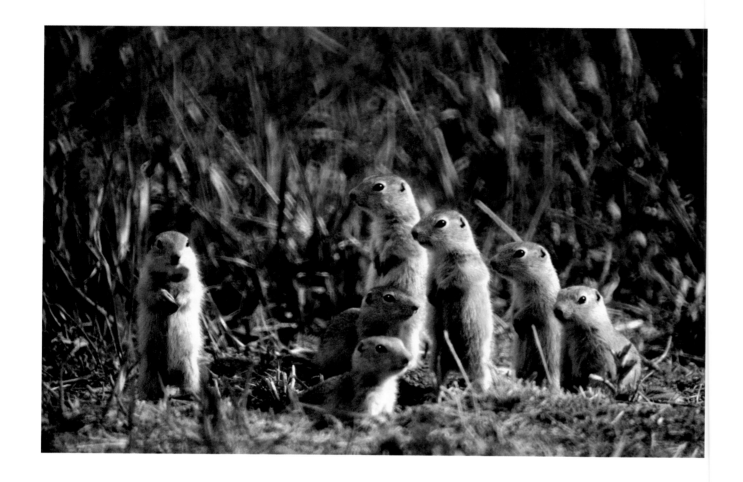

By mimicking a high pitched squeal, much like their danger signal, I call this family of gophers to their burrow. While they stand waiting for my next command, I quickly got their portrait from my open kitchen window (minus model release!)

THE DEFINING LANDSCAPE
an inner journey

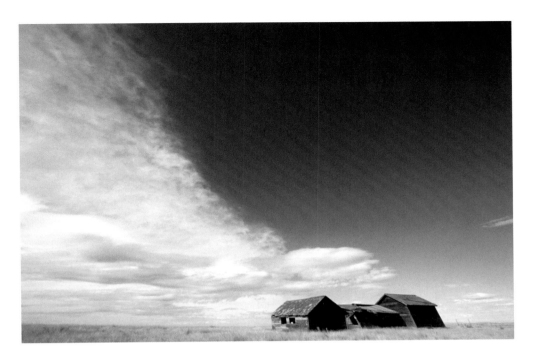

The Saskatchewan landscape has a way of wrapping itself around us. W.O. Mitchell understood this relationship when he noted that artists and writers put their signatures on their images and descriptions of the land, but the land, in turn, "signs" them.

We are blessed to live in a province composed of so many moods—a remarkable amalgamation of geography, season, space and light. In few places do the forces of nature have such impact on daily life, and in few places are people so keenly aware of their relationship to the land. We are moulded by the vagaries of the elements, our mythical parents the earth and sky.

Wherever we look across this land, the act of creation carries on amidst evidence of the ancient past. Each cycle of the seasons and every passage of the sun remind us that we are transitory but that the land endures. And throughout all our experience, this luminous landscape always teases us out of our occasional complacency, kindles our greatest dreams, ignites our wildest passions and, above all, bathes us in radiant light.

This chapter, then, is something of a creation story. In it are some hints of our profound spiritual relationship with the land as it forever renews itself. You might even glean some insight into why every year, about the same time, you fall in love with the first blue pools of spring in roadside ditches or venture out through knee-deep drifts hoping to spot the season's first crocus on a sunny hillside.

Whatever our journey, we are always drawn back to the land, the defining feature of us as a people. Our hope is to arrive spiritually at a rainbow awash in colour with our collective dreams stashed at the end, just over the next hill or in the middle of a green meadow that we call Next Year Country. Rainbows hold hope and promise because they contain every hue of the spectrum. They are the tangible embodiment of all things, reminding us that as custodians of the land, we hold the key to infinite possibility.

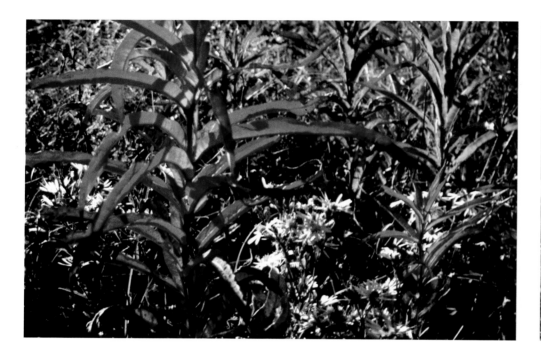

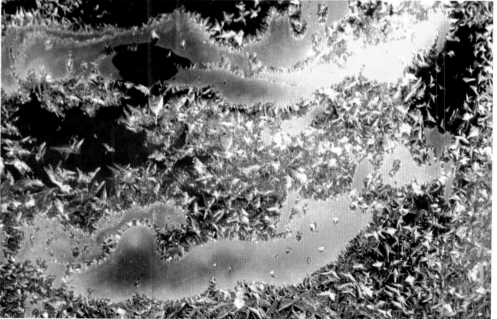

Saskatchewan's centenary in 2005 will be marked by many celebrations, but perhaps none will be as impressive as the march of the seasons across the land, especially when Earth dons its autumn finery for a last display of colour before Jack Frost takes up his brush to paint the windows with glittering frost.

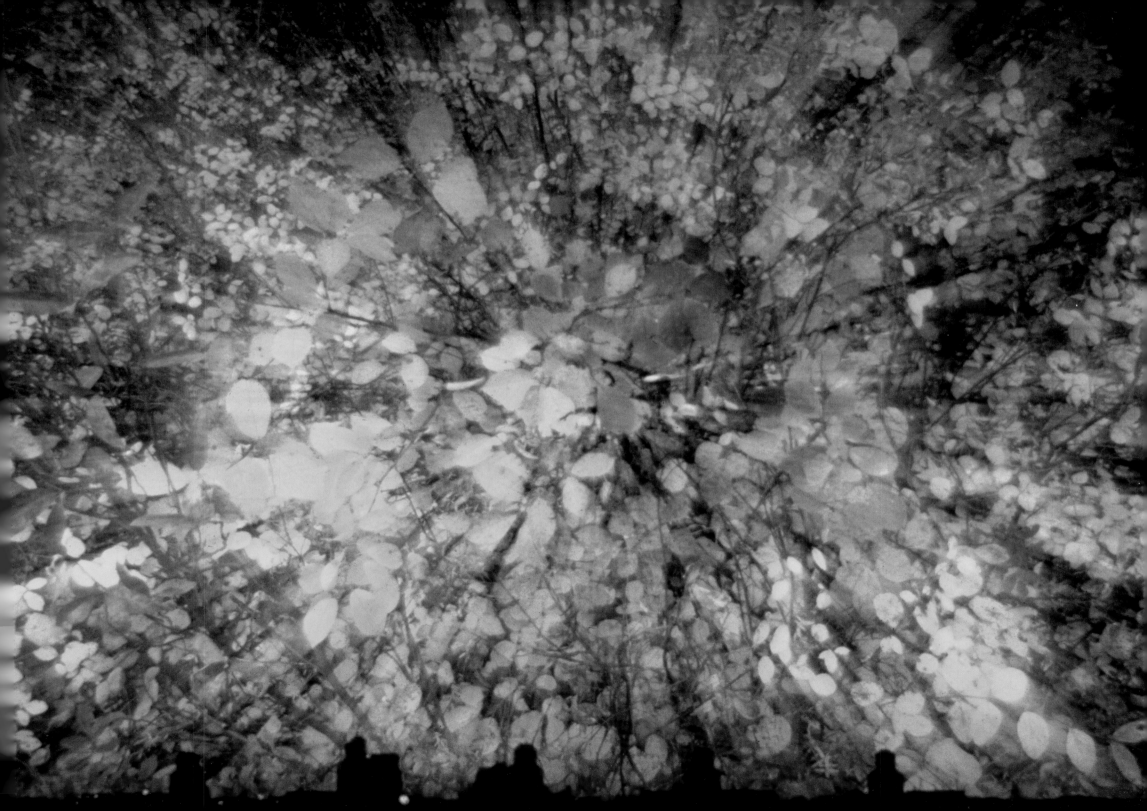

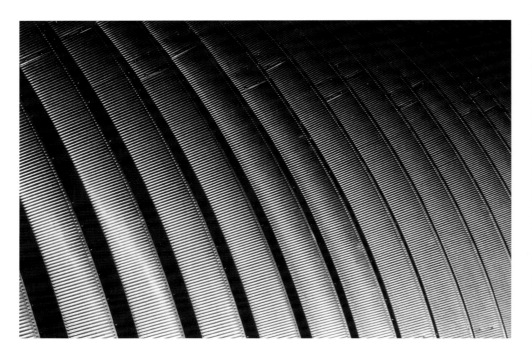

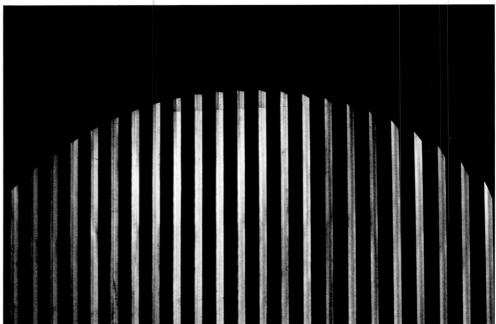

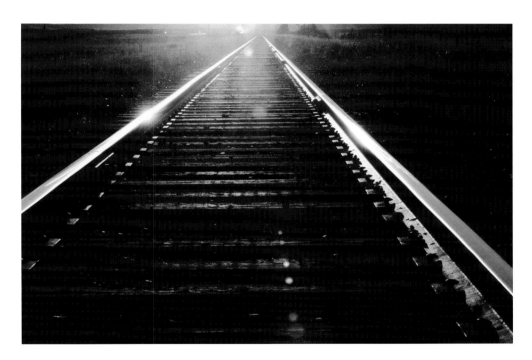 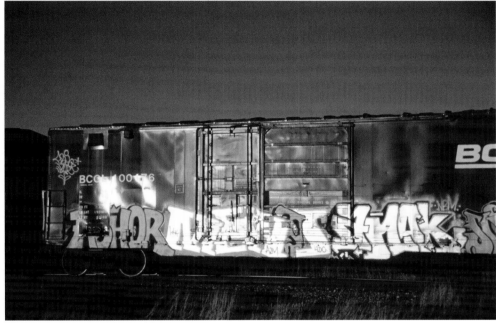

Steel produces strong, durable structures resistant to the elements, but on a sunny day they become beacons on the landscape. I love to work with the special geometry of early morning or late-day light on such surfaces.

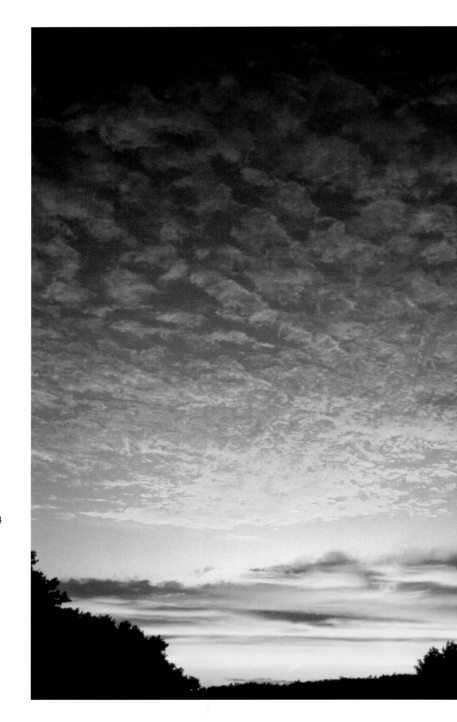

124

Some Saskatchewan sunsets are utterly memorable. Most of the rest are just simply run-of-the-mill spectacular. After a quarter century of photographing throughout the world, I have learned that perhaps only Central Australia can rival Saskatchewan for brilliant skies.

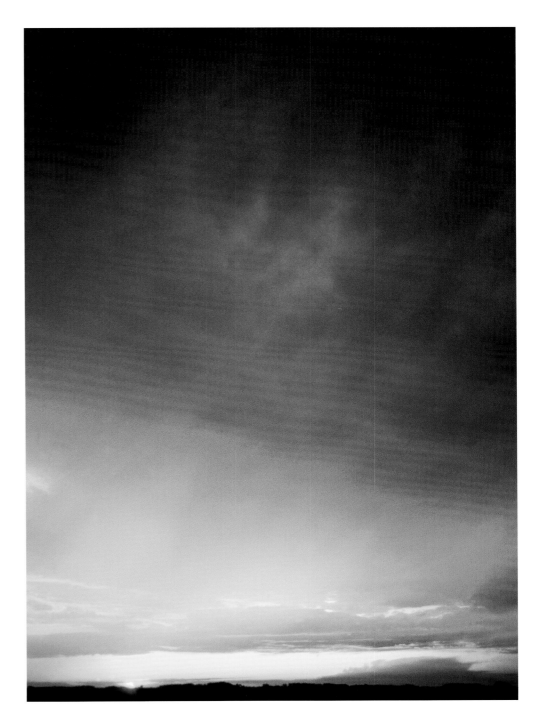

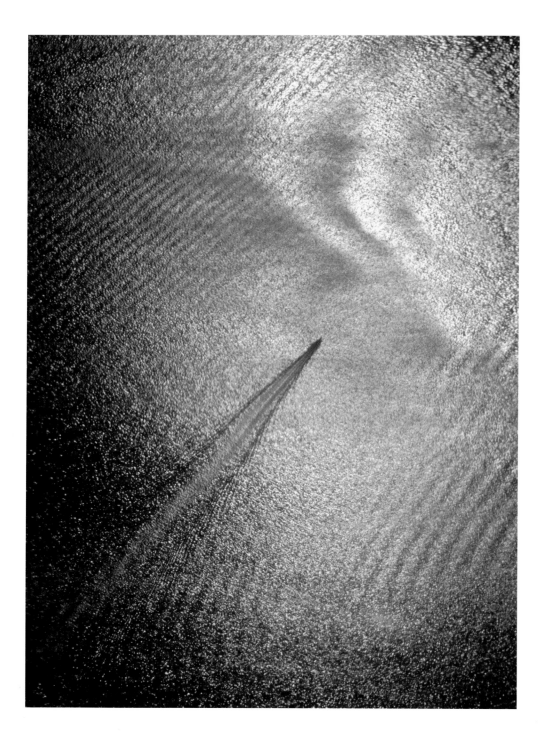

▸ The dreamlike play of light on water is always captivating. One evening, as I sit on the bank where Beaver Creek trickles into the South Saskatchewan River, I am engulfed in silence and light. My response is to record the golden glow with a multiple-image filter on a medium-telephoto lens.

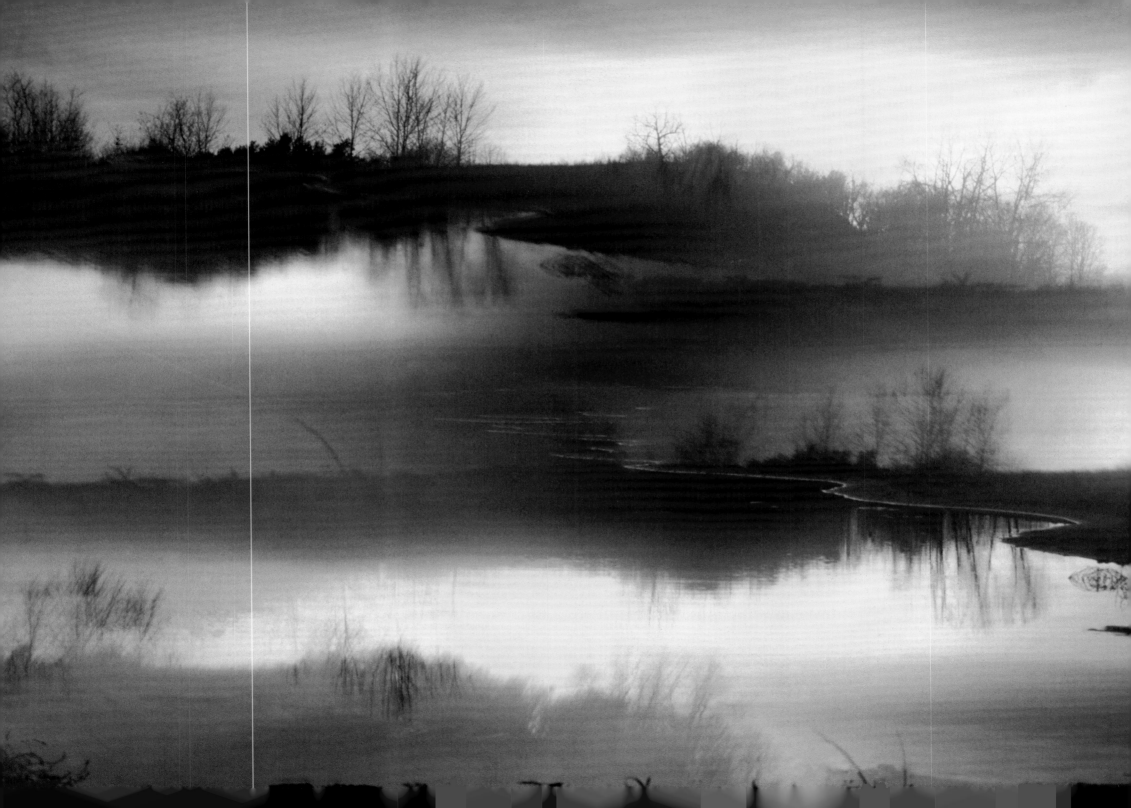

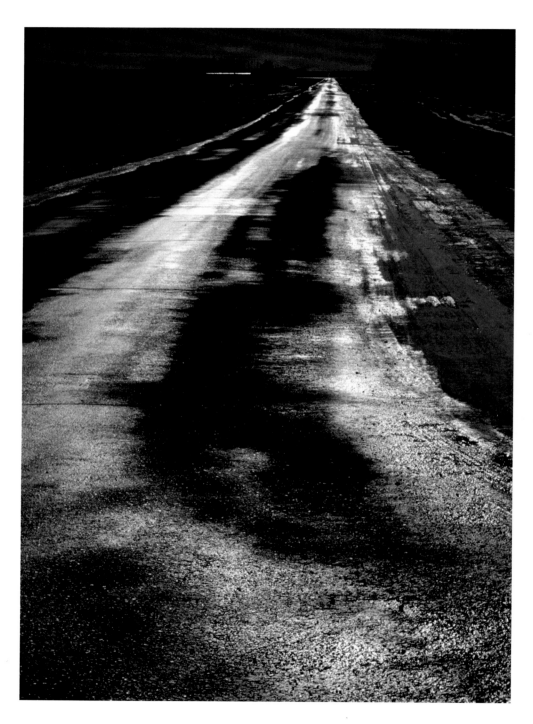

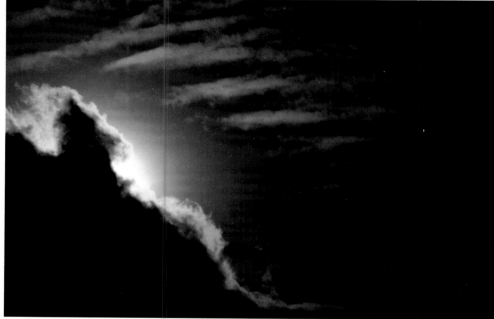

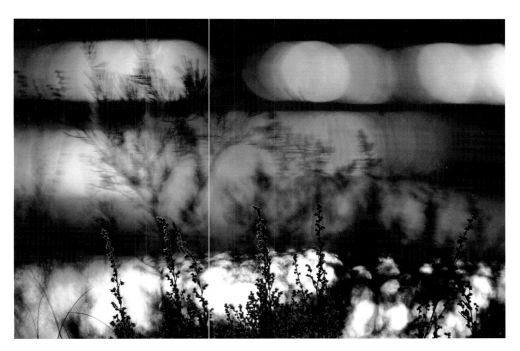

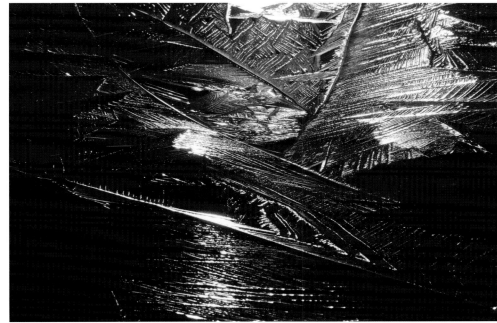

Some of the luminosity of our landscapes comes to us as hand-me-downs. In all these low-key photographs, I purposely exposed for the highlights in order to reveal aspects of reflected light often too bright to be noticed with the naked eye.

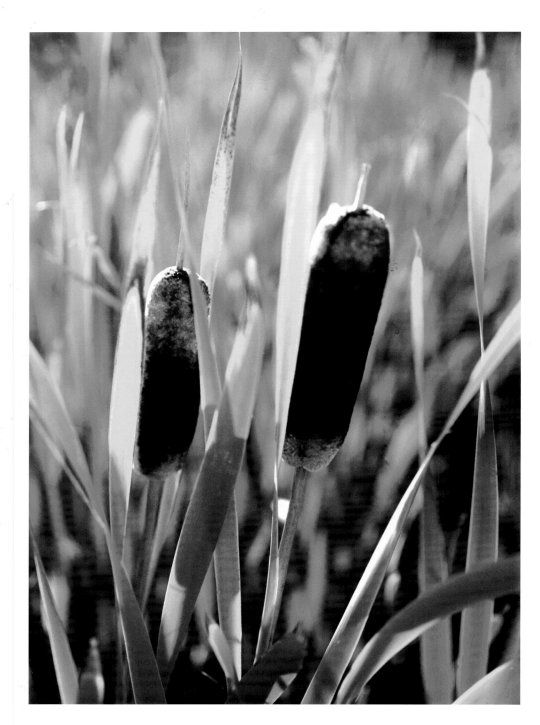

The margins of meadows and marshes are alive with colour, sometimes intense, sometimes subtle. Watching the play of dappled light on cattails or peering into a prairie lily, our provincial flower, reignites our delight in the colours of the natural world for their own sake.

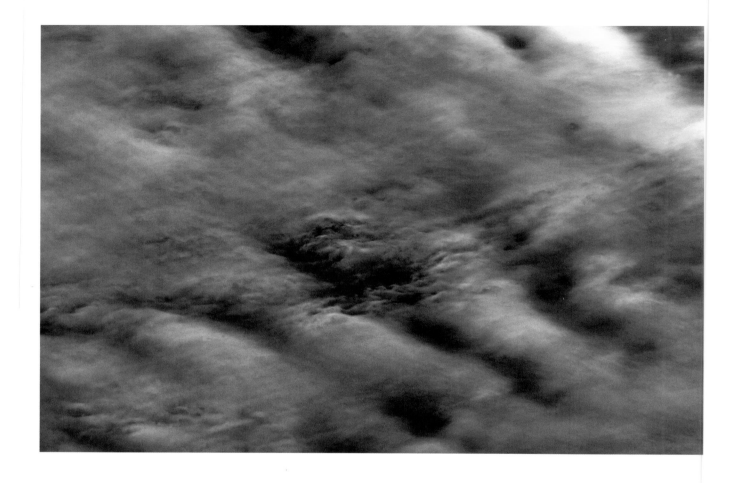

132

Sunbows, a word I coined for rainbow colour in clouds near the sun, are something akin to unicorns and auras: They are things most of us miss most of the time. Yet sunbows exist high above our heads and can be seen if we wear sunglasses and shield our eyes from the direct sun.

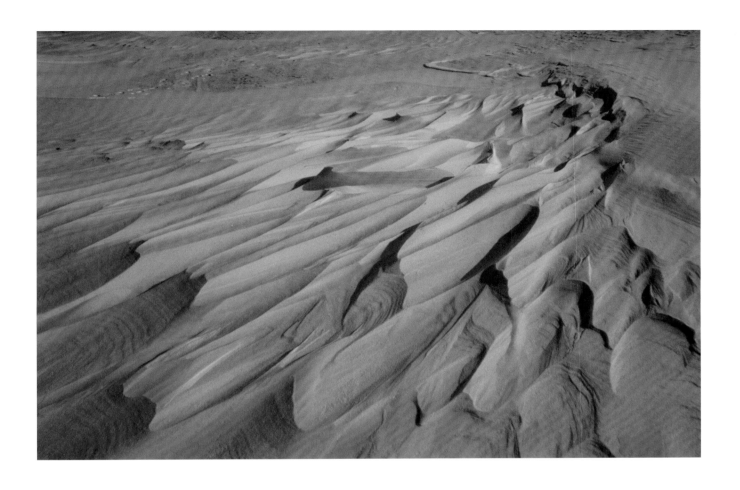

A moonlit stroll in February is a great way to be reminded that even in the dead of winter nature never stops creating new patterns on the land.

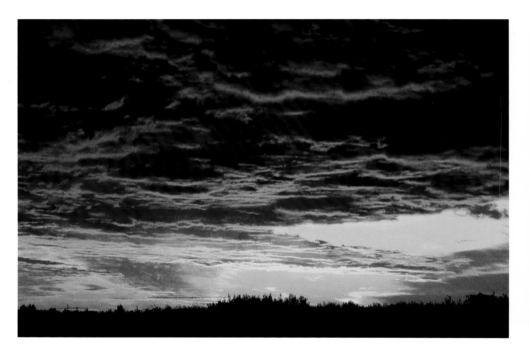

Recent United Nations research concludes that fifteen of the twenty-four global ecosystems are in decline. As our planet, especially around its large urban centres, becomes more and more polluted, Saskatchewan is emerging as a place to heal the spirit. Here are some samples of its colour therapy.

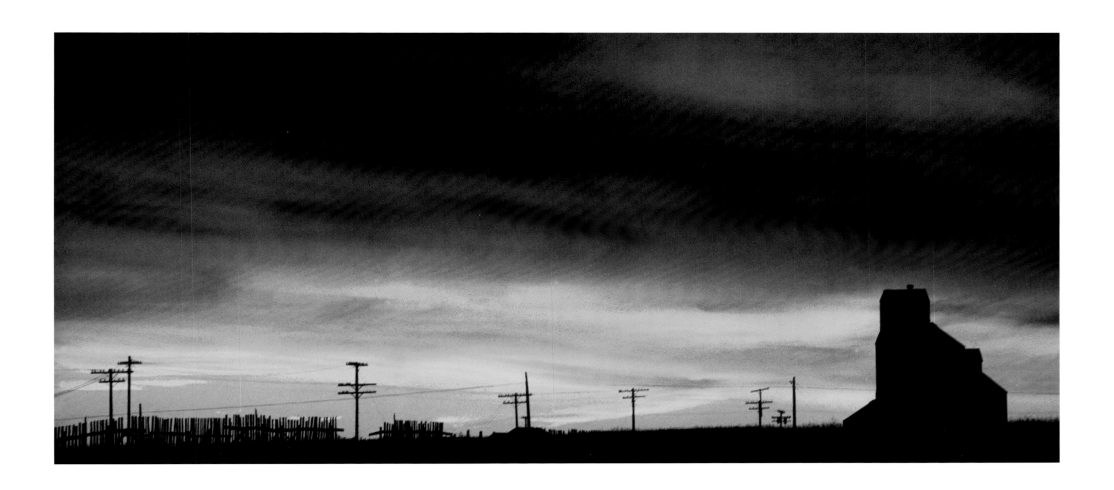

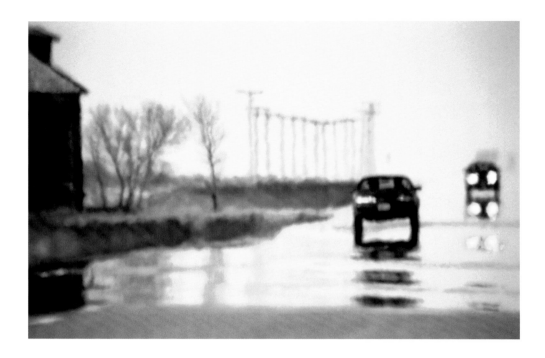

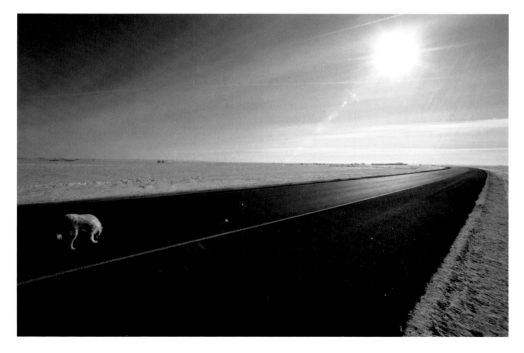

Mirages, though commonly associated with stories of the Sahara Desert, are actually a common occurrence in Saskatchewan's summer heat. Perhaps their cosmic purpose is to keep us vigilant, always recognizing that we can't rely on first appearances.

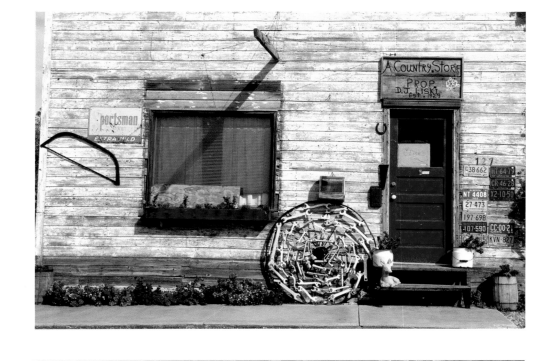

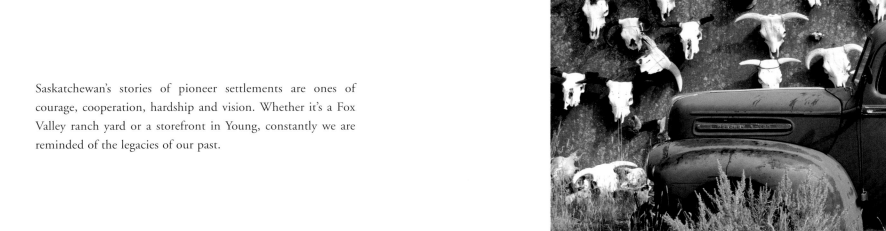

Saskatchewan's stories of pioneer settlements are ones of courage, cooperation, hardship and vision. Whether it's a Fox Valley ranch yard or a storefront in Young, constantly we are reminded of the legacies of our past.

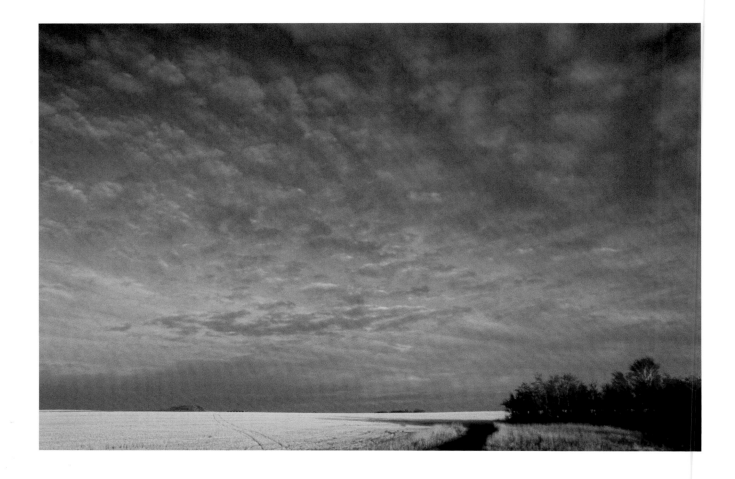

Sometimes when I am out with a group of photographers, we become so fixated on the western sky at sunset that we forget to look behind us to the beauty of night stealing across the landscape.

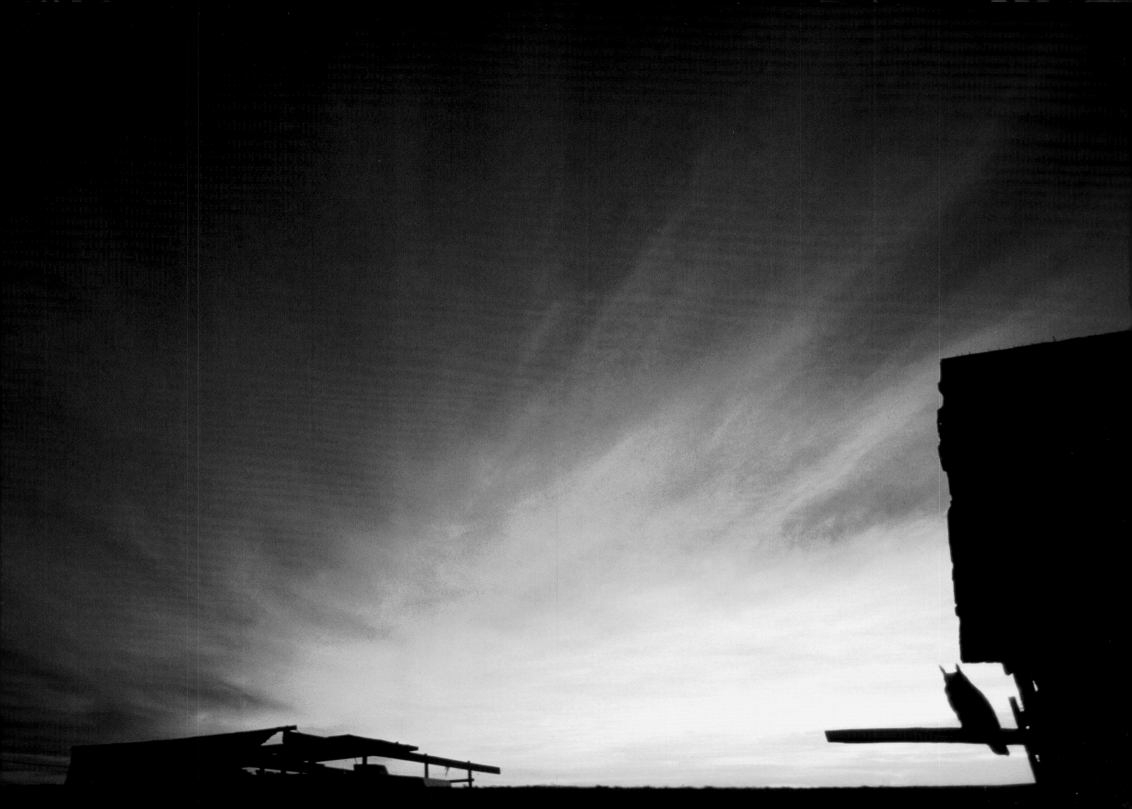

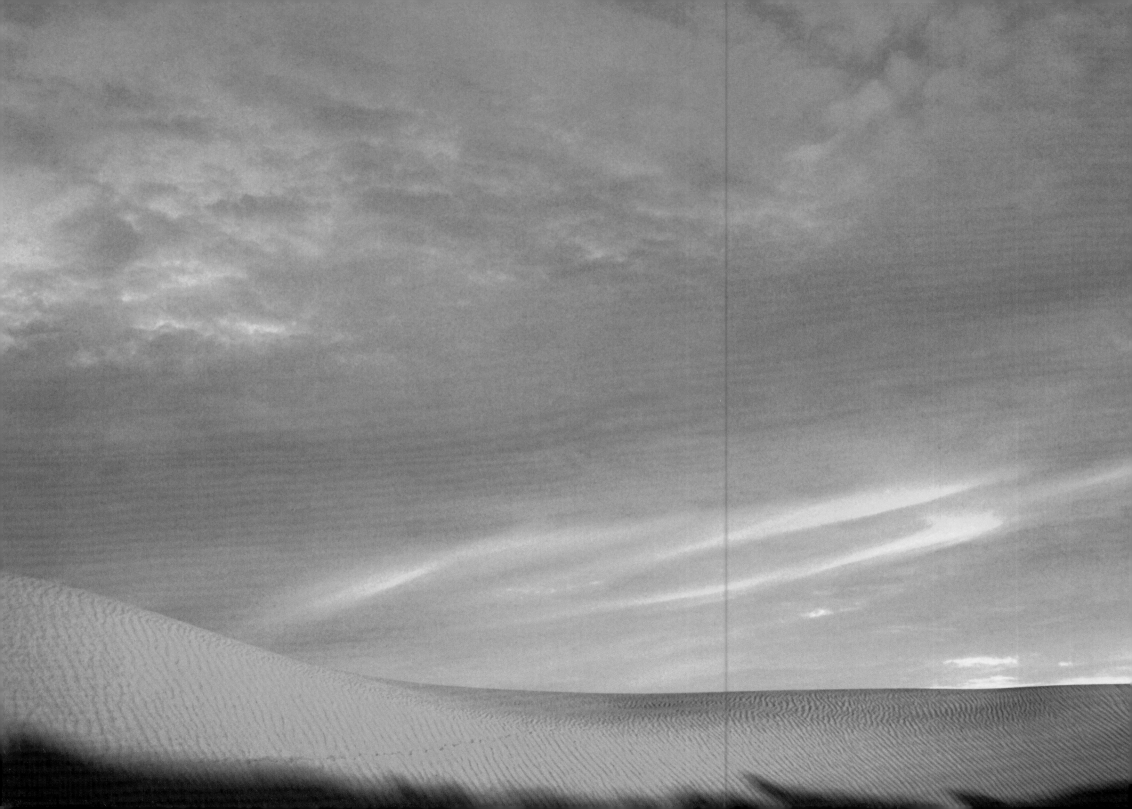

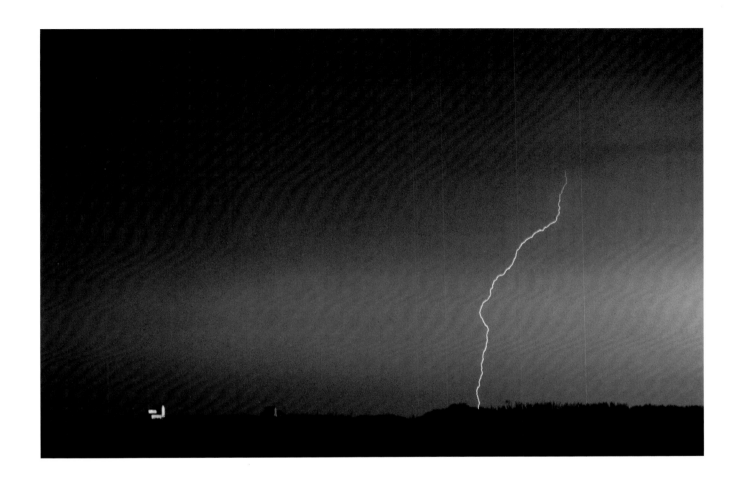

Thunderstorms in the south come in many shapes but are available only in one size: XXXL! At these moments, the flash of lightning and roar of thunder bear witness to the awesome power of the land and to the forces that continuously shape our lives.

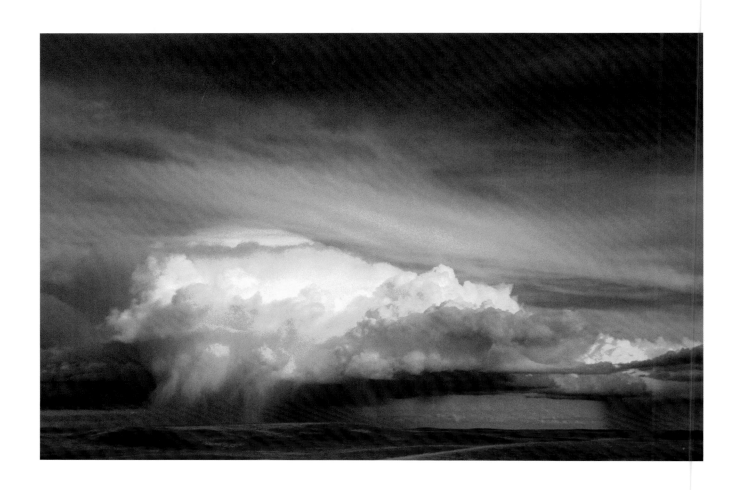

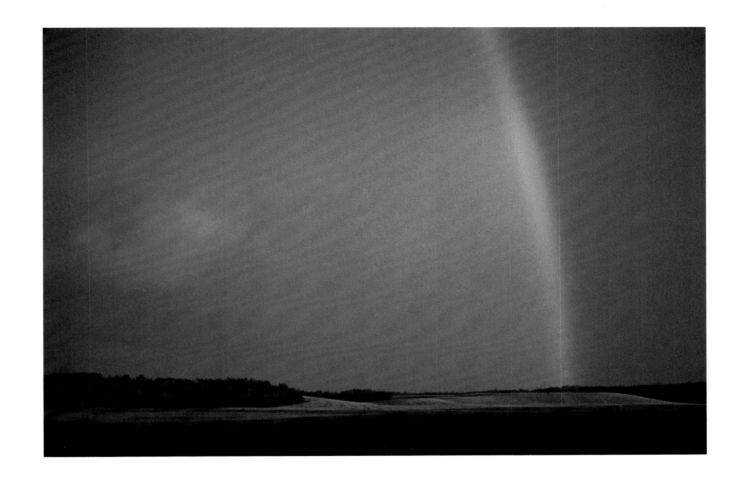

The Saskatchewan landscape must be experienced in all its moods—the light and the dark, the storm cloud and rainbow—to truly know this place we call home. Once imprinted on our psyches, no other land can ever feel like home again.

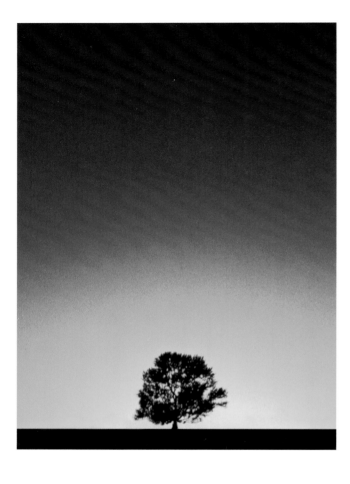

144

In celebration of Saskatchewan's Centenary, Courtney Milne, with the generous support of SaskTel, is gifting the schools and residents of Saskatchewan with an archive of his favourite provincial images.

Endorsed by Sask Learning and the Saskatchewan Teacher's Federation, this extensive archive will be a permanent online resource.

All of the photographs in this book can be accessed online at **www.coolscapes.sk.ca** using the following reference numbers: